CERULEAN

MW00851654

CERULEAN

LJ LaFleur

Copyright © 2019 by LJ LaFleur
Images © 2019 by LJ LaFleur

Cover Design and Images by LJ LaFleur

All rights reserved. Printed in the United States of America. No part of this
book may be used or reproduced in any manner whatsoever without written
permission except in the case of reprints in the context of reviews.

ISBN: 978-0-578-62555-3

www.ljlafleur.com

Published by Halcyon Press
www.halcyonpress.co

To Mara,

You will always be loved and you
will always be missed.

To Alex,

Thank you for showing me it's okay
to feel again. Thank you for show-
ing me how beautiful it is to live.

And to a Poet,

Cerulean is for you.

TRIGGER
WARNING

This book contains material relating to:

High-Functioning Depression
Anxiety
Complex-PTSD
Alcoholism
Eating Disorders
Child Abuse
Stockholm Syndrome
Suicide
Trauma (including sexual, physical, emotional and psychological)

Please practice self-care during and after reading.

CONTENTS

"There is no blue without yellow and without orange."

-Vincent van Gogh

Part One

"My god, that's a lot of avocado on your toast—"

"—Avocado is a good fat though."

Standing in my kitchen, I looked between my sisters as they discussed what I should be eating and how much. Then down at my toast, I stared hopelessly. The gluten-free bread that's half the size of normal bread. The one, small avocado that was used. The two pearl tomatoes diced on the top.

I barely ate anything today.

Taking my first bite, I swear I couldn't taste,

The gluten-free bread that's half the size of normal bread.

The one, small avocado.

The two diced up pearl tomatoes on the top.

I barely ate anything today.

Maybe I shouldn't eat at all.

"You're not the kind of woman he would go for."

"What?"

"You're not—you're not..."

I stayed silent as she continued.

"You're not the billionaire type, babe. You're not blonde enough or skin-ny enough. Guys like that don't go after girls like you. That's not how it works in this world. He was attractive, like model-level attractive."

What she was really saying was: You're not that. You never will be. It's silly to think that you could be anything prettier than the bag of bones given to you.

Closing my eyes, I felt the lump in my throat enlarge and my tears swell. I had dropped twenty pounds, already thin and growing thinner with each passing day. Hopelessly, helplessly, I agreed.

She apologized but not for her cruelty towards me.

She apologized for having to go.

London was

calling,

And I was

falling.

But either way,

I wasn't the type

of woman my mother envisioned

for the man of her dreams.

you can do this.

bite,
chew,
swallow.

bite,
chew,
swallow.

bite...

It happened again.

Where I felt heavy,

heavier,

the heaviest.

Staring into the mirror,

I flattened my shirt against my tummy;

fear escalating.

Heavy,

heavier,

the heaviest.

Trapped in my mind,

I see an unfamiliar reflection.

My lips begin to tremble,

tears collide with my lashes

as I whisper,

"what happened?"

There's a moment,

where I want to curl into a ball

and beg for clarity from the heavens.

There's a moment

where I want to smash all the mirrors

but I don't need seven years of bad luck

because I couldn't stand my reflection.

Hopelessly looking into the mirror,

I hear their commentary on my body.

From my youth till now,

of never being the ideal size

no matter which way

I fall or rise on the scale.

Heavy,

heavier,

the heaviest.

I went to the spa,

to exfoliate their hate from my body.

I felt her massage

down my back and up again.

It felt strange,

like my ribs were sticking out,

stretching the skin thin.

It sounded odd,

the rumbling noise

my bones made.

How could that be

when I'm feeling

heavy,

heavier,

the heaviest?

EVERYDAY

IS A BATTLE,

TO NOT LOOK IN THE MIRROR,

AND SEE MYSELF

WITH DESECRATED ARMOR.

My bones,
won't let me
be any thinner.

My heart,
won't let me
break any further.

My soul,
won't let me
continue to wither.

So, here I am in a war with
my Mind and
my Body.

Calculating my every bite;
consuming and starving,
starving and consuming.

I'm exhausted, Love.
But still,
I survive.

FUCK

THE EATING

DISORDERS

AND THE

SOCIAL MEDIA

ACCOUNTS

THAT

PROMOTE

THEM

...and fuck the social media platforms that allow it...

...and fuck the glorification of weight loss that's plaguing us.

i couldn't love my body because they wouldn't
let me. i was too fat, too thin, too much
heart for a world of judges and jury members.
my image contorted in the mirror and this
house was no longer fun nor a home.

in limbo of having lost the girl i was and not
able to find the woman i'm meant to be, i fell.
falling from the sky, they don't tell you how
beautiful the drop is. instead they tell you
how painful the crash is.

but it's at the bottom of the sky, where
clouds refuse to venture, i find a sanctuary.
in ink and paper, i've immortalized my strug-
gles because one day, i'm going to fly again.
that's when i'll see the beauty of the sky
again.

i'd like to look back and down, to see how far
i've risen. i'd like to gaze forward and up,
to see how far i still have to soar.

i couldn't love my body before, but i'm learn-
ing. slowly. i'm engaging in healthy practic-
es, i'm remembering and wanting to eat. as my
wings keep growing, i see my reflection in the
mirror.

i've yet to become the woman i am meant to be,
but i'm getting there.

i drank too much last night.

flavored vodka shots,
lining them in a row,
to form another
of empty glass.

but i was happy
to feel something else;
the word stuck on the tip
of my tipsy tongue.

almost as if the dark within
had been put to bed,
so my light could
shine again.

How tipsy are you?

I just winked at my wine.

if you can't drown

the pain out with wine,

try bourbon.

that will make for a

brilliant,

awful

time.

i catch myself sometimes,

trying to drink my feelings away.

it's problematic to do so.

it's problematic because there's

a fine line

between drinking the problem away

and a drinking problem.

when i drink, i get these feelings of happiness
and joy and the clarity to understand the differ-
ence between the two. what's more intoxicating is
the numbness that i succumb to after philosophical
questions are answered with more shots and glasses
of wine.

i shouldn't drink because i saw what it did to my
father, yet somehow i understand him better by
continuing his toxic habits. his demons were of
war, mine of love (the lack of it). one of my de-
mons is my father.

under the surface of freedom and warmth and too
much alcohol, i see him. i see my father's bones
crushing with guilt and pain born in his youth,
and how it will follow him to his grave. i see my
father's skin turning grey, his cells morphing and
his eyes losing sunlight.

i watch him in my mind transform with liquor,
just as i saw him in my youth. maybe that's why
i choose to do the same. or maybe it's because
monsters are made until their DNA is completely
altered and their traits and habits are as deep-
ly woven into you, their children, as it is into
them.

wanting to escape myself because just like him, i
am my own demon. alcohol helps me outrun who i am
until i catch up again because there's always a
tipping point, you know? where the euphoric feel-
ing is replaced with stifled emotions. sometimes
its anger, but usually in my case, it's always an
inescapable sadness that engulfs me.

i've prevented myself from moving forward by not
addressing who i am. whose blood runs through me.
i watched my father convert into the demon he al-
ways tried to outrun. i don't want to do or be the
same anymore. i deserve more than a life of run-
ning.

drinking is an escape for me, but sometimes the
passage to freedom leads straight to hell. every
time i'm there, i crawl my way out whimpering,
with bloody fingertips and the beginning of a kill-
er hangover. i have dragged myself out from the
depths of who i am and the experiences that shaped
me.

however, i understand that i deserve more than the
ability and talent of survival. i deserve to live
peacefully. i deserve better than climbing out of
empty bottles and painful memories.

so, what about you?
come out from your
"safe space",
your hiding place.

what about you?
what are you writing
except for brave women
and your alcoholism?

i once told someone,
"of course i drink, i'm a fucking poet."
in that exact moment,
standing outside a chocolate shop in
vancouver, british columbia,
i knew i had a problem.

do you?

come out from your "safe space",
your hiding place.
emerge from the
drugs,
drinks, and
the darkness.

tell me,
when will you accept
that you have
a problem?

i've given you the gift

of immortality.

you've been absorbed,

caged,

in bricks of paper

and

bars of ink.

The sun had not woken, and the stars had not slept. You were inebriated, black-out, an absolute mess. I tried to heal you, help you, as you held your stomach and cried out for lack of control.

Do you remember what you did? You couldn't have. You were inebriated, black-out, an absolute mess. Rage spewed from your tainted tongue, and still I tried to comfort you. To heal you, help you.

Then the nightstand flew so hard it bounced off the wall, crashing into me. You didn't even bother to watch me fall. You chose to stare at the floor; did you hear the wood scream, or me? My tears building, bursting. My heart aching, breaking. All as my mother watched, doing—saying—nothing.

But I must keep you, merely give a warning. "A yearly pass," is what my mother said I needed to do. So, once, maybe twice, maybe three times you're allowed to act like that. Like this.

I should have left you after the first time, the second, then third. I should have left you after every year of hurt. I should have run or flown, but you had clipped my wings and chained my feet with the promise of Love.

You don't remember, but I do. Your words, your actions. I was never good enough to be loved by someone who didn't hurt. I was never good enough, to be loved. I was never good enough. I was never enough.

Do you remember what you did? What you said? You couldn't have. You were inebriated, black-out, an absolute mess.

He could never stand the morning doves.
Always threatened to shoot them—
"stun" them into silence.

I should have known then
that he would crush my wings,
and mute my song.

I should have known then
that all he would ever
Love
is
Violence.

there was a night
i needed you.
i texted, then called.
on the phone
i told you something wasn't right,
everything felt wrong.
you said
you would be home soon,
that everything would be alright.

burning up
from the inside
out,
i thought of how pain
makes you feel alive
but this kind of pain,
this will make you
want to die.
shower after shower,
all i could feel was my body
out
inside from the,
up burning.

exhausted,
i made it to the bed,
weeping beneath the sheets.
you still hadn't shown.
then you stumbled in,
sometime later,
with a drunken smile
and liquor on your breath.
you fell to your knees,
my knight in dented armor,
laughing at something your brother said.

sobbing in bed,
tears and sweat mixing,
"where were you?
i needed you.
i need you,"
i said.
your laughter seized,
your demeanor shifted
as you began to
guilt me,
numb me,
because it was your night of fun
that had ended.

the next day, at the hospital,
alone with the doctors,
they told me
i had an infection
but unsure of what kind.
i told them i knew...

...it's the man
with my father's eyes.

c e r u l e a n , p a r t o n e

i was never drunk with you.
not off wine,
life, or
love.
but there was one time
that i did drink too much
—wine, that is.

i wanted to remember
what it was like to feel alive;
i wanted to paint again.
quickly the glass
and bottle had emptied.
the sweet, delicious elixir
assisted in skewing my rendition
of what i saw outside.

stars were spinning, shooting
across the canvas.
it was so incredibly beautiful
being lost in my version of the universe.
i couldn't help but smile,
wondering if Van Gogh ever cried
when he painted at night.

then something devastating happened.
there was no room left to paint;
my canvas full.
i felt a fire in my blood,
the heat unbearable.

that's when i painted my body blue.
giggling at how nice it must feel
for stars to be surrounded by darkness,
their very own pool to cool off in.

you glanced over your shoulder,
knitting your brows together,
"what the hell are you doing?!"

"the paint feels good against my skin," i murmured.
you were so focused on your beer, on
your video games. i didn't think you'd
care. i didn't think.

you shook your head, calling me ridiculous
and to not get paint
on the carpet.

i wanted to hug you, hold you,
because maybe then you'd hug me back.
perhaps then you wouldn't be so mad.
you were wearing white;
it was my fault you snapped.

c e r u l e a n , p a r t t w o

ordering me to go shower
i could barely stand,
let alone cower.

you left me in the bathroom but not before growling,
"rinse off or else you'll stain the sheets blue."

you left me.
stumbling,
drowning beneath the water.
i could scarcely feel the heat
or the cold.
scrubbing my skin,
cerulean had stained
in patterns of stars and hearts.
of everything left
that i still loved.

you came back,
aggressively drying me off,
and demanded that i lay down.
was i laughing?
crying?
because despite being conditioned
to laugh and cry at certain times,
i knew
i wasn't feeling, not anymore.
as i staggered to our bed,
naked and still damp,
the spins had taken over.
you forced my pajamas on,
then guided my hand to
the wooden headboard.

i remember crying then,
not from lack of control but a terrible
feeling in my soul.

"what's wrong now?"

"i feel bad for the trees. the poor dead trees that were made into
furniture. do you think they'll haunt us for this?"

you repeated again
how ridiculous i was.
the color escaping the room,
all colors draining from me to you.

i asked my final question,
one meant for a warm, curious heart.
"do you think the universe is made of whispers?"

i can still hear your laughter,
mixing and molding
with the monsters of my past,
as if you finally found your home.

but that heart,
the warm and curious one like mine,
this portion is for you.

we'll have a bottle of wine and
paint the stars across our skin.
taking turns to paint one another (tell me that isn't romantic).
we'll giggle, sing, and dance like we're kids.
we'll discuss the questions hidden in our hearts;
we'll learn that vulnerability is an art.
neither one of us giving a damn about
staining the floor, the sheets, and walls with blue.
a little drunk and deep in love,
it's this night you'll realize
heaven isn't a place but a person.
the woman who gazes at the stars even in daylight.
the woman who has waited her entire life for someone like you.
the woman covered from head to toe in paint, in love,

in our cerulean dreams.

I still sleep with the lights on and the doors
locked, hoping that will somehow deter your ghost.
It never does. I'm afraid you have hollowed out
a portion of my brain to be your new home. I'm
afraid I'm riddled with holes because of you.

You knew of my past, and yet you chose to reenact
it. You knew of my past and yet every time I told
you what you do to me at night was wrong, it felt
wrong. You turned and twisted your way out of re-
sponsibility until it was somehow my fault.

Fuck you.

Fuck you for stealing what little security I had
left coming out of my adolescence. You get to
move on, you get to enjoy your life free of Com-
plex-PTSD and Stockholm syndrome. I get to live
in the same house where you stole years of my life
away.

I remain alone, afraid to sleep next to others
at night. Why I can only seem to have one night
stands and even then, I'm triggered despite my
hypersexuality born and bred from our years to-
gether. I remain alone with scars still bleeding
and waking up from night terrors screaming and
crying. But one day, I am going to overcome these
visions of you. I'm going to succeed...

...I did. In Italy. You were there, waiting for me in my dreams. How dare you try and ruin Italy for me. I felt your claws then saw your hazel eyes. *Enough.*

I reached for your face, digging my fingers into your eye sockets and pulled you down to your knees in front of me. I glared into your bleeding eyes and snarled, "don't fucking touch me."

There have been no nightmares of you since. An entire year of your hauntings, of waking up every night screaming, crying, drenched in sweat and thinking death would be a better alternative. I couldn't sleep next to my own sister because of you. And now, I'm still sleeping with the doors locked and the lights on but this is out of habit.

Fuck you.

Complex PTSD is this...

Waking up on top of your lover,
shaking them as you cry,
begging them to wake up
because you don't want to
watch them die.

Taking too long to realize you've only woken to
another nightmare.
In this one your lover doesn't comfort you—
especially at night.
Not when your body is his;
not when he's ensnared your heart
to feed his sins.

Covered in sweat,
profusely apologizing,
your vision blurring,
your entire body shaking.

He calls you fucking crazy.
"You're fucking crazy."
Then turns around
and falls back to sleep again, easily.

Complex PTSD is this...

Losing control
of your body,
your mind.
It was bad enough in your dreams
but now this has become your reality.

Horrified that it keeps happening
with no one to rescue you,
no one to console you;
no end in sight.

Your friends don't get it,
your family doesn't either.
They tell you,
"you're overreacting."
"You're thinking too much."
"Your therapist is lying."
"You're hungry, you're tired."

There's no one to console you;
no end in sight.
Scared of the sheets,
frightened of the moonrise.
You know this won't be the last time,
you know what's waiting for you
on the other side.

He snaps, "you're fucking crazy."
This is the same man who waits until
I'm asleep to fuck me.

Scared of the sheets,
of the memories;
triggered by everything.
Hard to breathe,
forgetting my beliefs
and dissociating from my body.

Complex PT...

HE TOLD ME THAT IT WAS GENETICS.

THAT'S THE REASON FOR
WHAT HE DOES TO ME IN THE MIDDLE OF THE
NIGHT AS I'M TRYING TO SLEEP—
WHEN I CAN'T PUT UP A FIGHT.

HIS FATHER DOES IT TO HIS MOTHER,
HIS BROTHERS DO IT TO THEIR WIVES.
IT RUNS IN THEIR FAMILY.

RAPE IS NOT GENETICS.

RAPE IS RAPE.

I said, no.

"What am I supposed to do now?" Those were the first words out of his mouth when I told him it was over. I had tried for a while to end things; he wouldn't let me. I had tried again last night in the empty dining room. He sat against one wall and I sat across from him, leaning against the other. Hanging above us was the bulbless, cage-like chandelier he picked out.

I tried...

He wouldn't let me say goodbye as he guilted me with his tears, he guilted me as he did when he proposed on the cliff-side. When I was choked with silence as the man in front of me turned into the monster I had always feared. I surrendered.

That night we went to play pool at a local bar. I was surrounded by men, all of whom I looked at with begging eyes to get me out and away from Him. None of them were listening. He guilted me again when I asked him to sleep down the hall in the guestroom. I stood my ground this time, I wanted to sleep through the night.

No one was going to save me but myself, that's what I realized. The next morning, I went to yoga, I went to therapy. I returned with my spine in the shape of a sword and I told him it was over.

"What am I supposed to do now?" I was not the love of his life. I was not his soulmate. I drained my money so he could keep his. I lost my body, my sanity and my will to live. I was the one who needed an answer to the question, "what am I supposed to do now?"

I was not the love of his life. I was not his soulmate. I was his meal ticket until he was too hungry to be fed by one woman.

If you want to know what it feels like to have your heart ripped out, learn that you were only their "soulmate" because you were serviceable.

"What am I supposed to do now?" Answer me.

Please...

Survive. So that one day, you can live.

i wouldn't stop fighting them,
twisting in bed, falling to the floor, until
they hoisted me up and
held me down,
with four hands,
twenty fingers,
and pillows—
a fuck ton of pillows.
it wasn't the red wine that did it,
it wasn't the mugs of glogg,
it wasn't the six shots of bourbon
after all.
it wasn't the empty stomach,
it wasn't the dancing,
it wasn't the cut off sign at the bar.
no, that's not what started this all.
i couldn't stop sobbing.
tears jumping into the cold bed
beneath me.
overflowing;
only getting worse as i said,
"don't leave, don't leave me alone."
"i thought he loved me."
"don't leave me."
"he raped me."
"i thought he loved me; he raped me."
"he...he...i thought he—don't leave me alone.
please."
"please."
"please..."
they told me he was no longer here,
no longer in my home.
they reassured me i was safe,
repeating it over and over
and over.

"you're safe now."
"he's not here anymore, he's gone."
"the locks are changed."
"you're safe, LJ."
releasing their grasp,
brushing my hair back,
placing the rubbish bin beside my bed.
but still i begged,
"don't leave me alone."
this was the night
i hit my low.
the bottom
of wine,
of bourbon,
of anything to numb the pain.
"he raped me," i whispered.
again, even after they left.
still in disbelief,
still pretending
my entire life hadn't changed.

you want to know what's lower
than low?
having to ask your
abuser
for grocery money
to survive.

sitting in your car,
sobbing in the parking lot,
with just enough food to get by
until you have to ask again.
and your abuser knows it,
enjoys it
when you beg.

you want to know what's lower
than low?

having to ask to survive.

I confessed to her
I hadn't been sleeping well,
I hardly do nowadays.
Even with the door
closed and locked.
Even with the
light on and music
playing nonstop.

She asked why,
what did I dream of?

I admitted,
it was the same
reoccuring nightmare,
the one of him raping me.
And no matter what I did
I could never escape his hands,
his words.
I could never escape
him.

My mother laughed,
then told me not to
drink so much water
before bed.

there are days
when i am exhausted of being
my own hero.
sinking into the sheets,
afraid to go to sleep
because i know what waits for me
beneath; the twenty-seven years of
darkness that haunts me.
drenched in sweat,
hardly breathing,
waking up to my dog nuzzling
me with her wet nose until i'm
gasping for air and
my entire body is shaking with fear.
drowning in lost memories,
drowning in relentless nightmares,
drowning to where my chains
are anchored in the deep.
sometimes i'm exhausted
of being my own
hero.
exhausted
of fighting to wake up, to
breathe.

"hold on," my encouraging heart says,
"soon the sun will rise,
soon the chains will break.
soon, you'll be embraced.
and the monsters will be afraid
of the fires burning their shadows away."

I spent the night on the floor, sobbing uncontrollably alone in an empty house. Staring at my pieces, I wondered how I was going to put myself back together. My body felt heavier than before, "how is that possible if I'm broken?" I asked outloud.

I couldn't reach my books for an escape; I wouldn't be able to read the words anyways. I couldn't reach the alcohol; I didn't have the strength to crawl to the cabinet. I couldn't do anything but lay there, listening to the cries that didn't sound like mine.

I spent the night on the floor, wishing my best friend was still alive to tell me, "be cool, it's all going to be alright." She would have known what to do. She would have grabbed the wine, she would have grabbed a book and laid beside me. We would have cried until we laughed and cried again. She would have held my hand and smiled through the tears.

I wish she was still here.

I spent the entire night on the floor alone, staring through the ceiling and up at the stars, asking them, "what was this for? What lesson am I supposed to learn from all of this? How fucking alone do you want me to feel in this world? Why—why me? Why is this happening to me?? Who is here to pick me up off the floor because I see no one? What the fuck am I still fighting for?"

My heart whispered then, "it's so one day, you can pick someone else up off the floor. So, you can tell them to be cool, it's going to be alright. It's because one day, to someone, you're going to make a difference in their life."

you experience shame after a situation like that. you weren't strong enough to stop it. your body language meant nothing. your words meant nothing. and so, your body was taken from you, until you are nothing.

"should", becomes your worst enemy. you should have done this; you should have done that. you shouldn't wear this; you shouldn't act like that. somehow, it's because of you, that it happened.

there's blame, there's victim-shaming, there's disbelief. the worst part is never being believed. yes, the shame you experience—the trauma itself—but throw in your friends and family not believing you. imagine them picking his side over yours. imagine losing every-one you love and thought loved you. imagine having no one.

as you sink to the bottom, you will wonder who will pick you up again because there's no one left...that's when your wings will regrow. the ones they crushed, the ones they ripped off—our wings will regenerate.

yes.

it's at the bottom of shame, bottles, regrets and not being heard...
that's when you'll get back up again. you'll remember your worth.
and without the weight of others, you will have an easier time flying
again.

it's baby-steps though. it's depression, it's anxiety, it's locking your
doors and thinking it will keep you safe from the demons in your
mind, it's complex ptsd...it's everything you will refuse to accept at
first.

but love, you beautiful soul, you will fly again. you will smile. you
will feel something other than pain. and if you no longer feel pain be-
cause a numbness has taken over, then i promise, you will feel again.
cold, shattered. warm, healed. you will feel again.

please, breathe. open your eyes and crawl out of bed if you must.
drag yourself to the bathroom, eat a piece of toast if that's all you can
manage for today. put on your clothes despite it fucking hurting to
have something touch your skin. before you leave for the day, don't
forget your crown.

you may be shattered, you may lack an army, and despite not believ-
ing in yourself, i believe in you. i fucking believe in you. now get out
there and conquer.

Sometimes I feel like
I'm the only one
who understands
me.

What if that's it?

What if I'm searching for
a soulmate,
but there isn't one for me?

What if out of billions
it's only me
with my light?

What if there isn't a soul like mine?
That my soul was never split in two
and I'm here walking this world
already whole.
Alone.

What if...?

What if the love I'm searching for
is only within me?

I should be happy.
that should make life easy.
But my arms can only wrap
so far around me.
My lips can only kiss
certain areas of my body.
And there are days,
there are days
when I no longer want to be here
because even this world
feels foreign.
Who then, will encourage me to stay?

I should be happy
if I am the only one
with a soul like mine.

I should be.

But sometimes—
a lot of the time—
all the time,
I just want to find someone
with a soul
similar to mine.

I want someone who
understands
me.

I want an Equal.

I did it. I left him. I always knew he wasn't my soulmate. I just buried the feelings with other people's expectations and with him, our families and our friend's opinions.

But before you continue, I only ask three things of you.

1) Do not judge me.

2) Do not pity me.

3) And do not fall in love with the pieces of me.

Because here is a spoiler, I'm not the same woman as I was a year ago. I'm not the woman in pieces that are scattered across these pages.

I'm a Queen, sitting on her throne metamorphosing alone.

These are my love letters from the soul. These are my love letters to my soulmate.

You'll find me one day.

Dear Soulmate,

Do you ever feel yourself drowning in a room full of friends who don't really give a shit about you? When you go home you can't escape the feeling. So, you sink and sink and sink until you hit the bottom.

I'm sure you have—how else would you be able to understand me if you haven't had the feeling? If you didn't have reoccurring visits from depression and anxiety, old toxic "friends".

I've been feeling exceptionally low lately, the longest I have in a while. I know it's because of past trauma working its way out of my bones but it somehow makes me feel heavier. I thought if trauma were leaving my system, I'd be riddled with more holes, which means I'd be lighter than before. Turn's out that's not always true.

I was on vacation recently and I was happy and adventuring—facing fears and meeting such wonderful people. I was living.

Then I was taking a bath and although it smelled like orange blossoms and lilacs, I began to wonder if I should just slip beneath the surface. Scream until my lungs filled with iridescent orange floral water. Scream until there were no sounds able to be heard.

Instead I stepped out of the bath, crying hysterically at the thought of traumatizing the housekeepers and...leaving you behind.

The idea of you roaming this world alone seems to always stop me. Of you trying to find me and never being able to—I can't do that to you. Even when I was a child, I always thought of you.

I rode out my feelings, I got on the plane and I flew back in pieces. The rest of the week, I felt angry and sad and controlled by my emotions—my old friends had come back with a vengeance.

One night, alone in bed and crying myself to sleep I began to wonder if you can feel me and I can feel you. Maybe it was all my own trauma, maybe it was feeling some of yours too. We may be separate bodies, but we are split from a single soul. One that wasn't created twice.

I want you to know that I understand the lows as much as I understand the highs. You're not alone, you never have been. When you're sinking, far away from the stars, to the bottom of the sea like an anchor—I want you to remember something.

I'm waiting for you. I'm here. We will have our time and it will be incredibly beautiful, however, it doesn't mean our lows will be gone forever. Toxic "friends" love to surprise visit us even at the best of times.

But I have good news for you, you'll be with someone who understands you. Someone who gets it too.

With years of practice trying to pull myself out of the deep, I'm going to tell you how I'll hold you up. First, it will be to remind you that our world will not be so burdensome when there's two spines carrying the weight. That my touch will remind you we have fire for blood, that stars and stories are flowing within us.

Next, I know how to make a damn good cup of tea; lemon juice, sliced lemon peels, rosemary, ginger and honey. It's a concoction that would scare winter warm.

I would leave roses and lavender on your nightstand, burn some Palo Santo and grab your favorite book from the shelf. When you lay on my chest, listening to the rhythm only you can create, you'll feel my fingers brush through your hair. I'll have stolen your socks and might be so inclined to apologize on days like this.

But if this doesn't work, do not fret. We'll go on an adventure.

Picnic made, blankets in the back of the car and facing the sea we'll head straight for the stars. I'll take your hand and not say a word as we walk towards the shore. And when the waves are crashing at our feet and tears are falling down your cheeks, I'll kiss them free.

Inhaling the sea, exhaling my story. It's of a girl who almost drowned but Poseidon saved her. That the chord had tangled her up and the waves wouldn't let her go until she hit the shore. She makes it, afraid and out of breath but she makes it home.

I'll explain that these waves, these feelings you feel yourself drowning in, will end eventually. You will make it to shore if you ride out your emotions, you'll always make it home to me.

And if that doesn't work. If you don't want tea or an adventure. If you want to lie in bed because your skin fucking hurts and you feel like there's no light in your days. If all you want is to sink alone; I would understand that too.

However, you will receive a letter slipped under the crack of the door. My body might leave you, but my soul never will, and neither will my words.

On your happiest of days and the darkest ones too—I'm here for you. To celebrate new beginnings or cry over bittersweet endings—I'm here for you. I was born for you, Darling. So, with or without me beside you, you're never alone in this world or the next. Not in happiness, not in pain. I'm always with you, even oceans away.

Your Equal,
LJ

"Do not fade away," she said as her eyes blazed at the darkness within me.

I could feel the little fire within flicker towards her.

Say it...

"Do not wither. Do not shrink. Do not let them win. For you are a Queen, and Queen's do not bow, *they rise.*"

FUN FACT:

LONELINESS

CAN BE CURED

WITH SELF-LOVE

AND

MINT-CHIP

ICE CREAM.

being alone is frightening until you realize

we live on a ball in space

with seven billion people

who all feel the same

she told me
what i didn't want to hear,
the truth.
where all my disorders stem from,
my roots.
why i starve
to stay small,
why i binge
to stay whole.

at home
feeling the thorns pierce through my delicate skin,
i curled up on the floor, fetal position
with my gentle hands cradling my head.
tears flowing
through the cracks between
my palms and cheeks; fearlessly falling.
crying the weight off of me,
hoping the trauma will follow.

what i didn't know then was
i'll rise
and i'll bloom
always
towards the light.

I have these love lessons I've written.

Notes from myself.

Notes for others.

Notes for you.

I hope they help.

I truly hope they do.

<u>Love Lesson #1:</u>

Losing weight has always been perceived as positive in this society which is disheartening for us who have eating disorders and/or body dysmorphia. Why? Because when you do gain weight to be healthy, you sometimes descend into madness, old habits, etc.

I lost a significant amount of weight because of my eating disorders and then gained fifteen pounds back. At first, I was having panic attacks, becoming mentally and emotionally crippled because I had to be weighed at the doctors so frequently. I could see the numbers flashing on the screen; I didn't know that you could refuse to be weighed. I should have refused. Unable to escape myself, fixated on my stomach, thighs and biceps—it became increasingly difficult to outrun my pain.

I grew up knowing how much food to leave on my plate to not receive their hate. I grew up with never being good enough no matter which side of the scale I was on. Toxic comments, side glances, and heartless interrogations; I was drowning. I once had an ex-lover tell me he was "looking out for me" by watching what I ate and how much. But it wasn't only those closest to me, it was strangers on social media, in restaurants and in fitting rooms. There was no sanctuary for someone suffering like me.

I was drowning in toxicity—in a reflection that was no longer mine—correlating my weight with beauty as my family and lovers had always taught me.

Beginning my downward spiral after so many months of hard work, a dear friend of mine asked what was wrong but all I could do was hold my stomach and cry. She then replied, "when a baby is growing inside of you, will you be this cruel to yourself then? Or to her? Just wondering."

She hit my weak spot, my wake-up spot.

Though that question isn't a wake-up call for everyone, I do hope you can understand the gravity of it. She took it another step further by asking if I was ready to take a photo of myself shirtless and sitting naturally (this is when I began to sweat profusely; some people are terrified of sharks, I was terrified of a close up of my stomach...and sharks).

I did it. After looking at the photos and comparing them to the ones from the beginning of this year when my eating disorders had nearly won, I was speechless.

I had let my trauma win another battle and the only way to heal (to win) would be digging to my roots and finding the little girl within. To finally show her the love she was never given.

There was a woman that I was speaking with recently who had a weary smile and broken eyes. I noticed that she had lip injections, hair extensions, eyelash extensions, microbladed eyebrows, breast implants, etc. She is the absolute perfect woman according to today's beauty standards of our society (especially on social media).

But what hurt me was that she was looking at me as if waiting for me to tear her down like so many others had done in her past. It broke my heart; I knew that expression all too well. She didn't expect my kindness, but it was amazing watching her transform within a few minutes.

Her confidence increasing, her smile forming, steady eye contact—all she needed was someone to be kind and accepting of her. That's all we really need isn't it? Acceptance for who we are.

Since then I've begun to look at my body differently.

I made a list of what I love about the frame that encases my soul and maybe you can make one about yours too.

What I Love About My Body:

Though I barely have a belly roll, it's there when I sit and it's there when I look in the mirror. Belly rolls are soft and feminine and squishy and cute. They remind me that I'm finally eating again. They remind me that I'm cooking for pleasure and that I'm a damn good cook too.

My body is riddled with scars/stories. I'm a fairytale come to life. Mine may not be beautiful to many, but they are to me. I clawed my way out of hell and lived, my scars are just proof of it.

I love the scar on my lip that makes wearing lipstick nearly impossible. I love the scar on my ring finger, the one men always tried to cover up with diamonds so it would be beautiful. I love the ones that are above and beneath my skin, every inch of pain made permanent. I especially love the ones on my chest because it means I was given a second chance to live.

I love that I have cellulite because it reminds me that I'm not only made of the stars but the moon too. Have you ever heard anyone complain about the moon's craters? How grotesque they are? No, neither have I.

I love that when I'm at the beach my constellations of freckles and beauty marks and sunspots keep the sand company and my stretch marks look like the waves always kissing me. I love that my hair is as wild as seaweed and that on my back, close to my heart, I have a gorgeous sunset for a birthmark.

If you're rolling your eyes because you believe I'm thin and can't possibly understand what it's like to struggle with weight, please remember our eyes see the world differently.

What I view in the mirror and what you see through a screen, are not the same. That is why body dysmorphia is difficult to explain unless you have experienced it firsthand. However, I encourage you to go to a funhouse (the one with all the funny mirrors), look at how it distorts your image. Hopefully, that is as close to understanding as you will ever get.

Please take the time this week to view yourself with benevolent eyes and speak to yourself with loving compliments. See the magic in every part of you because it's there just waiting to be discovered.

You're beautiful, I promise you.

Part Two

cerulean:

look up.

no, not the definition

on your phone.

up, outside.

that's the color of

his eyes.

i think.

i saw him once in a dream.

i've been chasing cerulean eyes

ever since

hoping to find him again.

you're out there,

just not here.

i want you to remember this day.

you're reading every word

on every page,

your breath is held every time

you could relate,

and your heart aches every time

you can't see my face.

Dear Soulmate,

Thank you, for not being here just yet.
For giving me the time
to breathe,
to be,
to regrow my wings.
There are depths of me
that I've yet to discover
and I'd like to explore myself
further before I let you in.
I'd like to be whole again,
perhaps for the first time
in my life.
You might have to wait a bit
longer, for that I am sorry.
But I promise you
when the time is right,
I won't be scared
of the jump,
the fall,
the flight.

Keep dreaming,
keep living,
keep loving.
You have no idea
how proud I am of you,
how badly I just want to kiss
you, to hug you.
To be with you.
But our time will come
and when we see each other,
promise me
you'll take my hand,
graze your thumb across my
knuckles and fly us
Home.

Your Equal,
LJ

I am your dream girl

And I am real.

Hello.

I'm sure you're curious about me. So,
I made a list (I love making lists,
that's the first thing).

I love when it rains, and the sun re-
flects off every bead on the wind-
shield as I drive home. Reminding me
that the stars are not so far.

I love wearing sweaters in the winter
and also in the summer. I'm always
cold. Let's cuddle.

I drink more tea than anything. Water
is lovely, but imagine adding chamo-
mile? Wild, I know.

I love dancing in the middle of
restaurants, grocery stores, and
parks. By myself or with someone
else.

I love that I can see the light when
it's dark. It's my magic trick I've
cultivated into art.

I fall like the moon, cold and vul-
nerable. I rise like the sun, warm
and whole.

I love that everyone keeps forget-
ting to look up at the sky and study
the clouds. I swear I learn more from
looking up than down.

Roses and lavender and magnolias.

Stargazing.

Mint-chip ice cream.

Gennaro Bottone chocolates.

Van Gogh.

I love walking, especially through
cities, countrysides, and shorelines.
I resonate with Elizabeth Bennett
more than I once thought.

I love those who practice kindness
everyday and want to make a differ-
ence in a good way with good inten-
tions.

I love listening to the sound of my
typewriter. The keys trying to keep
up with my fingers and my fingers
trying to keep up with my mind.

I love that I have relentless hope
in finding you.I love that one day I
will.

You have so much to learn about me
and it will take you much longer than
reading this. But I am your dream
girl (freckles and all) and I am
real.

Hello.

I don't understand dating in today's world. How you must charm the other through texts, posts and comments. What life is that?

If that's the future of love, then that's not what I want. I can't imagine that's what anyone wants.

But a love letter. Poems. Breakfast at noon without taking pictures of our food. Lying in bed with afternoon tea and scones. Traveling the world, areas we've been to and the ones we've never seen before. Making love on every surface, never feeling the cold.

Writing in comfortable silence. Reading to one another, arms and legs entangled on a blanket outside. Sitting beside the sea, listening to our heartbeats. Endless touching, no matter who looks our way.

Lost in one another's eyes, not needing to say a word. Comfortable silence. Working in the garden, until our knees hurt. Deciding if we should stay in or join the world, but unlike Gatsby and Daisy, we know our worth.

Painting when drunk, our bodies turning into a canvas. Inevitable fights but working things out, together. Missing each other when we're apart, but never caging the other, never guilting the other for leaving. Learning French and failing until we're decent. Learning Italian and failing until we're decent. Learning Mandarin and failing.

The music records, my god! The records we would collect, the records we'd listen to and dance to all night long. How you'd twirl me around and around, until we'd both fall to the ground laughing.

Bookstore hops in every country we visit—bringing back more books as if our home isn't filled with enough of them.

Kissing. Dreaming. Living.

Learning piano and feeling your fingers on top of mine. Cooking meals together rather than going out for fancy dinners because as much as I love to do that, I adore creating something together, something with you.

Sharing a bath. Laughing together—hysterically until we can't breathe. Breathing. Watching Doris Day movies because you know how much they mean to me.

Then eventually, when the time is right no matter how much time has passed, saying, "I love you," and meaning it. Saying, "I love you too," and meaning it. Never really needing to say it, because we show it every day.

That's what I would want.

How about you?

"I've worn a mask my entire life," I uttered, feeling my tears carve their way towards my chin.

"You did it to survive, remember? You survived your family, your friends, your lovers. I'm so proud of you for making it out alive. But…"

"But…?"

She pursed her lips to the side, a sign she always made before dropping the painful truth. "How would it look to finally be yourself? I think you're ready for the world to see you—who you truly are."

I rested my wet chin on my bony shoulder, staring out the window, "I'm scared to let people in." Studying the clouds, the scars of the sky, I braced myself for her reply.

She gently touched my arm and beckoned me to look at her, "it has taken years for you to let me in, but you did it. Can't you see how beautiful you are? Can't you see how much you shine?"

I didn't know what to say, so, I remained silent.

"Promise me, that you won't hide forever. I know it's a survival technique that you've used for twenty-something years but maybe instead of trying to just survive, you can live peacefully. And maybe you can let your soulmate find you a little easier because it has taken me years—years, LJ. I can only imagine how long you would make him wait to unveil yourself."

Laughing at her exaggerated eye-roll, I smiled, "I won't hide anymore, promise."

I told him,

"I don't believe anyone in this world has
the capacity to love me the way I Love."

And he looked down, digging his fingers
into the grey sand as he replied,

"I don't believe that's true. I think he's out
there, just waiting for you."

When the Universe splits a soul in two, can you imagine hearing her cosmic explanation?

"You will be separated, released into a world of grey. You must find one another, with time as your boundary and Love treated as a game. Good luck, you two bodies, may your soul one day be whole."

How painful do you think it felt? To split in two? To forget what we're told, then meeting all these people who could be "the One", to only see lies unfold?

How my heart aches, for the lost part of my soul. For he is out there, loving fully, not knowing it's me he's searching for.

Dear Soulmate,

I've redone this letter over fifteen times. Too many things I want to say that it becomes chaotic on the page. Pages and pages, it was overwhelming looking through them.

I wanted to write to you about how the mundane things in life are not actually mundane but important. I wanted to write a dream scene of us just living a Sunday kind of life. I wanted to explain why I'm not there beside you yet.

All these topics have taken hold of me and want to burst out of my body. So, this is how one letter became three. I hope you enjoy reading these as much as I love writing them. I hope they bring you some peace.

It's hard to imagine that our magnetism hasn't torn the world apart for our souls to permanently collide. Sometimes I think souls feel one another, love one another, even from a distance. Maybe that's why I don't fear being without a soulmate, I know you're out there. Somewhere.

There's been a lot on my mind since I've been sick. I couldn't hear, I couldn't read. I was lying in bed and all I could do was sleep and think and sleep and fucking think. Random things popped into my head, giving me relief from my nightmares at least.

Like I've always wondered, what have we all been through to be so kind? Every benevolent person I have ever met has been through one hell or another, sometimes more than once.

I've always wondered, is that why we're kind? Because we don't want another soul to go through what we've endured? I know I certainly wouldn't want someone to have my past. No one deserves that.

It frightens me what you could possibly have gone through. How I couldn't be there to save you. If you ever have nightmares, even in the daytime, I'm here. Miles apart or oceans away, wherever you are—I'm here. Thinking of you. If you have been through hell, once or twice or more, I hope you know that I understand what it's like. I get it.

I hope you know if the demons ever come back, I know how to fight them. I've had plenty of time to practice. If your demons ever come back, I can keep you safe. Monsters dislike like the sunlight and I happen to be made of the sun, of every star in the sky.

If you've ever asked the Universe why your soulmate isn't there, why I'm not there with you yet, I can give you the answer. I'm still healing from all my years of abuse, Darling. I'm trying to heal so quickly but six months isn't going to change a lifetime of patterns and a history like mine. Trauma doesn't disappear in one night.

I'm so sorry that you've had to wait this long but I'm worth it. I'm always worth it, even when others didn't think so.

I asked the Universe long ago to give me some time to heal before being with you. I was too frightened that I'd mess it up. I was too scared because I wasn't ready at the time to feel so much.

Not only that but I was never told that you can be a work in progress and still love and be loved. I was never told much of anything regarding love when I was growing up. I'm new to this, all of it. Everything I thought it was, is not. I'm happy to have learned this before being with you. I'm relieved that I'm untangling the knots of my past, so you don't have to.

We deserve a summer love that lasts a lifetime. That's why I asked the stars for more time. That's why they obliged. Please never lose hope in me. I'm just trying to catch up.

I hope you won't view me as helpless and broken, especially when I'm being vulnerable. It takes every ounce of me to do so. I didn't grow up with vulnerability, with kindness, with love. I grew up alone. I grew up with cold hearts, large bank accounts and an enormous amount of guilt. I grew up without my memories. I grew up alone.

I hope when you hold my hand that you wonder if time no longer exists, too lost in my eyes that even the world silences for a minute. I hope you'll look at me and see petals and thorns, bravery and light, beauty and benevolence.

I hope when you study the scars across my skin, that you admire how they glisten beneath the moonlight. All of them are beautiful but not all the stories behind them are. I'll tell you them one day, at least the ones I can remember.

If you ever question the stars, asking them why you've been through so much pain in your life, why you must wait so long to find your damn soulmate. Maybe now you'll realize that to understand me, you had to go through something devastating. You must be able to have the capacity to love someone as special as me and I must be able to do the same for someone as special as you.

We need to wait because we both need to heal and grow a bit more to love one another the way we deserve to be loved.

Darling, one day our time will come, and our eyes will lock onto one another like magnets. That's when we'll feel it. Time and Fate finally interweaving our destinies.

Your Equal,
LJ

Dear Soulmate,

I'm here
waiting for you.
I like to believe
that you're lost in a sea of stars.
Drifting, enduring,
searching.
From time to time,
you find a shore to rest upon,
but something is always missing.
Either the sand isn't smooth enough
or there are jagged rocks instead.
Rocks tearing apart the soles of your feet,
leaving you bleeding—
heartbroken.
At least you tried, Darling.
There's beauty in that, in your infinite
hope for Love.
Others have waves
either dismal or colossal
but when you finally reach them,
the shores are deserted.
Never have you found your sanctuary,
your beach to call home.
So, you return to the sea of stars.
Drifting, enduring,
searching.

You're exhausted, you've been
swimming for so long.
I promise you,
there's a shore out there
created just for you.
The waves are inviting, calm,
as you approach.
The sand is soft, warm,
hugging your toes.
The sunsets are life-changing,
with colors you've never seen before.
I'm here
waiting
for you to collapse in my arms.
I'll kiss you softly to
heal every one of your scars.
I'll brush my fingers
through your sandy hair,
singing to you,
"welcome home, my Darling.
Thank you
for traveling so far."

Your Equal,
LJ

It's like
chasing stars
in daylight,

searching for a
touch that feels
as natural as
mine.

Searching for a
Love as deep
as the universe.

Searching for a
Wild and Benevolent
heart in a
time plagued with

swiping left or
swiping right because
Connection

is too heavy and
too much, too soon.
Connection is taking part
in "losing" parts of you.

So I will
chase my stars
and hope they'll

one day soon
lead me to
You.

you poor soul

all you want

is to be

seen.

there's a different

spectrum of colors

buried in your eyes

so, in them i fall

to explore

every shade of blue

i never knew.

sometimes i wonder
if it's just the same two souls
that have been recycled,
the same two lovers writing about love.

that every turn of the century,
we're reborn
and taken on this journey.
separated at first, lost in a world of muted colors.

but we always find one another,
we always have our time,
and we always write.

sometimes i wonder,
when will it be our time again?
because i can tell you now,
i'm going to love you like this is our last.

last embrace,
last kiss,
last dance.

i'm going to love you,
as if we never get another chance.

I want someone...

Who wants to take me skinny dipping beneath the moonlight.

Who will softly hold my hand, knowing I'm still frightened of the water.

Who feels me tensing the farther, deeper we go.

Who pulls me in close, reminding me he'll always keep me safe.

Who makes me laugh to scare the fear away.

Who's gentle with his hands, even softer with my thorns.

Who doesn't expect anything more than a relaxing swim with his Equal.

Who is so damn nervous all we can hear is the thundering noise of our heartbeats.

Who brushes his thumb across my jawline; his affection endless.

Who's surprised when I slide my fingertips low, low, *lower*.

Who sucks in a breath, feeling a galvanizing shiver crash through his body.

Whose necklace entangles with mine as he lifts me up to his height.

Whose lips collide with mine.

Whose body forms with mine.

Whose soul reconnects with mine.

I want someone

Who wants to make love

With me

In a sea of stars,

Beneath

The moonlight.

Dear Soulmate,

Have you ever seen moldy peanut butter?

I haven't.

Your Equal,
LJ

can you picture it?

us
lying in bed,
close as can be.
sleepy eyes,
soft smiles,
synchronized heartbeats.
me, running my fingers through your hair.
you, rubbing your thumb across my rosy cheek then lips.

until
you can't bare it any longer,
being this far away from me.
you kiss me as
your gentle fingers trail downwards
inflicting shivers across my body.
a map of stars, of freckles,
i feel you connect each one.
patiently, lovingly,
as if you're the moon,
waiting to embrace the sun.

darling, can you picture it?
us,
living our days
exceeding our dreams.

yes, i can too.

my wings are beautiful.

black and white feathers
dipped in stars,
shaped into daggers
but soft to touch.
large and abundant,
never will they be torn from my flesh,
never will they be caressed by claws again.

i'm not sure how fast you'll fall for me,
if it will be my whiskey-colored eyes,
my petal-soft lips
or my golden dipped
wings.

if you've ever wanted to kiss an angel,
make sure you know how to
fly.

i'm not sure how fast you'll fall
for me,
but don't forget
we fall
before
we rise.

Dear Soulmate,

Does it hurt knowing that I'm out here but not there, with you?

To converse with about your day, your demons, your angels, hopes and dreams? Or to just stay silent, not having to worry because I understand exactly what you mean?

Unable to have a bottle of wine with me as we stargaze until the sunrise? Our limbs entangled, our laughter making the stars shine brighter and you asking for the sun to sleep-in a little longer?

Does it hurt spending your nights with others and not feeling completely satisfied? Something always feeling like it's missing even at the happiest of times?

Does it hurt knowing that I'm out here but not there, with you?

Wrapped up in your arms and never feeling as if I'm the elusive dream girl but the one made for you, born for you.

How you can't be held and reminded that when your life feels like it's falling apart, you have a Queen who would take on empires to make things right?

How you can't interlace your fingers with mine, feeling time stop as our hearts synchronize? Receiving an endless number of hugs because I know what it's like to grow up without them. How I'd never go a day without giving you one—even if we're separated by continents.

My laugh, my giggle—does it hurt not being able to hear such sweet sounds? Or what about not seeing me bare in bed beside you, softly smiling in the beautiful morning light as I ask, "coffee, tea or me?"

On the bad nights, when your nightmares come back to life—how I'm not there to hold you and reassure you that monsters are as scared of the light as we are afraid of the dark, that's why the Universe created stars.

Does it hurt knowing that I'm out here but not there, with you?

Dancing to old records or in random places around the world? How you can't cook with me, behind or beside me? Somehow making everything we do, normal everyday things, that much more intimate? Eating a meal with me, across from me with a little vase of flowers in-between us?

What about taking a bath with rose petals and oils, me leaning against your chest and singing Christmas songs even though it's the middle of June?

Unable to read to me on a blanket outside beneath the sun, beneath a shady tree. Immersed in Fitzgerald, Bukowski, Hemingway, Stevenson, Angelou and Prévert. Debating who is the best writer and ending our discussion with us making love because all of them are brilliant regardless of our opinions.

Unable to walk in the rain, in Paris?

Unable to walk in the sun, in Paris?

Unable to walk in the moonlight, in Paris?

Not being able to walk through cities and countrysides and deserts, together?

Adventure, together?

And you can't skinny dip with me in the sea? How you can't kiss me on the beach, covered in salt and sand and blissfully happy?

Does it hurt knowing that you can't make love with me? Gentle, deep, passionate—the kind you're thinking of right now? How it's making your stomach sink then float, your heart flutter and those damn galvanizing shivers racing up and down your body? Unable to hear my moans, my screams of ecstasy, your name off my lips—every sound I make? Unable to feel me, touch me, taste me, see me. See every part of me?

Or how about getting lost in my whiskey-colored eyes? Inebriated by how I view the world? Intoxicated by my mind, heart and soul? Lost and a little drunk, but finally home.

Even worse, does it hurt knowing you can't keep me safe? That you've never been able to. If only you knew that the hope of you is what has gotten me through.

Are you afraid that you'll fuck up and runaway because I am the woman you've been searching the world for? Are you afraid that we'll jump, fall and fly at the same time? Are you afraid you might actually find your Equal?

If it's a yes to all the above...

Well, me too.

Your Equal,
LJ

If you'll consent,
I'd like to take my time
in kissing you right.

Crescent petals
finding their way
across your skin.
Healing the scars
we cannot see,
loving the ink
only surface deep,
and embracing your darkness
with the light from me.

I'd like to kiss you
until every star
burns dark,
until the last song
is sung,
until the Universe
grows young.

I promise to let only Love
surge from my soul
to your lips.

I promise to keep you warm,
to keep you safe,
with every magnetic kiss.

A love poem for you
is not enough.
So, I'd tell you what I'd do
to show you my love.

I would gather every star,
beckon them from the sky,
lay them at your feet
so you could hear them sing
your lullaby.

I would take you to the sea
on every shore,
of every country,
and kiss you deeply.
We'd make the ocean jealous
of our love,
of the depths
it will never reach.

I would take your hand,
steer us towards the clouds,
making it our home,
high off the ground.
I'd give you all of me,
of all you desire.
Then again and again
until the sky is on fire.

A love poem for you
is not enough, Darling.
But one day, someday,
you'll feel the way
I love.

i once had a dream that

i had moved to paris,

to the city where i long to be.

a frenchman was sweeping me away to

his bed; drunk off lust and wine,

i had agreed.

exiting the café,

i stopped when i saw him

the one.

sitting at a small wicker table,

his wine glass nearly empty and his

beautiful eyes meeting mine.

time no longer existed,

the poor frenchman no longer existed

and the world i would soon come to love

finally

came into existence.

I had been walking alone all day around Paris. I was on a mission to find all the bookshops I could. I wanted to see why *Shakespeare and Co.* has such a prominent name in the book realm (I certainly found out why). I wanted to learn where the French go for their books (found that out too). I wanted to track down my favorite book that I collect in every country I visit, *The Great Gatsby* (and I did).

On my way back to the hotel, shivering in my beautiful blue coat and polka dot scarf, I saw these two. He was very frail and she was quite the opposite. But in love, in arm and arm, they walked.

It made me wonder how long they've been walking like this, together. How in the summer were they hand in hand? And in the winter, arm and arm? Does the cold bring us together, closer, like this?

Studying them from a distance, I wanted to know their story. How long did it take for them to find one another? How many years were they given to love one another? What a priviledge for those to be in love and love for generations. I wanted to know but I was afraid to ask...my French is practically nonexistent when it comes to continous conversation. For now, at least.

Despite the blisters enlarging across my feet, I smiled. They were living their love story and for a few minutes, I was able to as well. I should have asked how long it took for them to find one another...but

I guess that's the beauty of Love, never knowing when it will come.

In the kitchen,
when we cook,
I imagine a mess of sauce and noodles.
A splatter of red,
on your shirt and mine.
Across our faces, stomachs, and thighs.

You'll have me on the counter,
spreading my knees,
pulling me closer, till I can feel you tease.

You'll say how adorable I am,
to make such a mess.
You'll say how sexy I am,
and ask if your tongue can taste test.

Then down on your knees,
you'll lick up the inside of my thigh.
My breathing ragged as you tell me how I taste,
with your insatiable moans and
I tell you how it feels by my scream and
the flood onto your lips.

But it won't stop there,
no, Darling,
we have an entire kitchen to clean,
an entire menu to test.

My future Lover beware,
your stomach might have
an endless growl,
but your taste buds will always be
satisfied.

will you have tea with me?
lying in bed,
naked and complete?

will you read with me, to me?
an adventurous, lazy day—
rooted within white sheets?

when the birds are singing
and the sun
shines through the window,
will you paint me forever
in your memories?

will you hold me gently
in your arms,
nuzzling your nose and lips
safely into the back of my neck?

will you whisper
beautiful poetry
across my skin?

will you teach me
what it means to feel safe?
and when the moon begins to rise
and the birds softly
sing their goodnights—

will you listen to my story,
one that will leave tears in your
eyes?
it's of a woman
who has been searching her
entire life to lay next to you
on a warm, summer night.

Dear Soulmate,

I'm lonely sometimes. A lot of the time is what I truly mean to say. It's difficult to piece yourself back together alone, with only your own hand to hold, your own heart to hold. And my heart is heavy, but I believe it always has been.

Waiting for you, it feels like forever and yet it's only been twenty-seven years—it's a blink, a blip—it's not long at all. But it doesn't take away the feeling like it has been lifetimes.

Being away from you, however far, I have to remind myself that finding myself in another's arms won't bring me peace. It won't bring me you.

It might fill a night, maybe two or three, but every touch isn't right. It feels like nothing. I can tell the temperature, the softness, the bumps of scar tissue and ink, but I don't feel anything.

Does that happen for you too? You can feel connected in conversation, even looking into their eyes you are given access to their soul but it's the touch—always. Sometimes loneliness fools me into believing that I'm feeling something when really, I'm not.

I hope we find one another soon. I hope we no longer fill our lonely nights with souls who do not belong to us. I hope when we touch for the first time, we're both a bit stunned until comfortable. Like we've had lifetimes of touching one another and finally, we remember.

Our nights (and days) will no longer be lonely when we find one another. Will you be as nervous as me? Men don't make me nervous and neither do women. After all I have been through, there's very little I fear. Apricots? Yes. Saltwater Crocs (they can go in the sea and on the land and jump out of water? Are you kidding me??) Absolutely. People? No, never.

I've already been exposed to so much cruelty that there is nothing else that can be done to me that hasn't already happened.

Then there's you. I have a feeling I'm going to find it difficult to remain cool. That my charm might blow away like a leaf in the wind and I'll be infuriated by this.

How dare this man take my words and create a new world for us with them. How dare he touch me and leave me breathless. How dare he make love to my mind and heart and soul before ever kissing me. How dare he take his time in loving me right, in every way I deserve.

Well, Darling, what I mean to say is...I dare you.

Your Equal,
LJ

Dear Soulmate,

"You're safe with me."

I don't believe you will understand
the gravity of this statement.
The only words that I cherish,
that have retained any kind of meaning.

"You're safe with me."

Is the equivalent
to, "I see a future with you."
To, "I love you."
To, "I want to marry you."
To, "I want to have children with you."
To every normal, big, proclamation of
love that is said
by couples around the world.
By some sort of magic,
these sentiments have all been condensed
into one sentence.

I have never,
in my entire existence
felt what it means to be safe.
So, please,
please...
do not let these significant words
leave your beautiful lips
unless you can deeply understand this.

An, "I love you,"
is not the same to me.
You must show that;
I'm a visual learner after all.

An, "I love you,"
is not the same to me.
Anyone can love anyone
to some degree or another,
but not everyone can protect you.
Not everyone will.

You'll want to say it,
from our first interaction
and every single one that happens next.
You'll want to silently tell me
by touching me,
reaching out
in any way you can,
so I can feel the warmth of the sun
from your fingertips.
You'll want to softly whisper it
across my skin when we first make love.
From my lips to my neck,
to my sternum and each breast,
down my body and up again.
You'll want to—

—but please, I beg you,
until you know
the impact you will have,
do not declare
the last of all the words
that mean so much to me.

Darling, promise me,
you'll profess them only
when you're ready, to take on this
herculean task for me.

Your Equal,
LJ

embracing arms
folding me safely
into your chest and
without a scream
without a sound
except for a
single heartbeat forming

we fall

waiting on the inevitable collision
two stars burning across
the night
two flames burning the
darkness bright

we fall

your lips descending
my lips ascending
and together
towards the sea
reflecting the image of
lovers, the lovers of
ink and infatuation
paper and poetry
words and whisky

we fall

Working on a collaboration with a dear friend, I found myself wondering what "home" means to me. I couldn't think of something current despite living in a house that doesn't feel like mine. I couldn't think despite having a body, having friends, and different variations of what others might call home. Yet it doesn't seem right.

So, what the hell is "home" to me then?

And even now, as I type this out months later, I feel its shifted again. That because of my recent experiences, I needed to change the original letter.

I didn't want to be the girl who was too impressionable and went along with what any lover wanted me to be. That isn't fair to me, to my own soul nor to theirs.

I've learned over the past few months, that I'm not the girl who is too impressionable, no.

I'm the woman who finally sees her home. The woman who is taking great strides in creating her Own.

Dreams. My home are my dreams. Keep reading.

Dear Soulmate,

Home.

In the literal sense, it's quaint. A cottage made of stone and old wooden beams. One filled with immense history and preferably ghost-free.

The kitchen, the bedrooms—everything—is small but the library (let's be honest, the entire cottage is one). A copious number of books; our distant neighbors will wonder if we're hoarders, but I'll like to call us, "collectors."

But this kitchen, there's a rustic wooden table constantly covered with fresh fruit from the garden and orchard. Yes, I want an orchard. One that includes orange trees especially. We'll take what we have to give to those in need, reminding them life can still be sweet. I'll be reminded always, that an entire universe of kindness resides in your gentle hands and heart.

Goodness, I'm in love with this kitchen though. Some of our best meals and memories will be made here, together. I can see it now, the one of me crying over the stove attempting to soothe the screaming children and trying not to set our home on fire—and absolutely failing.

You'll put out the flames, kiss my burned fingertips and remind me you like your pastries extra crispy (liar). I'll smile, knowing I would've waited lifetimes for someone as wonderful as you. We'll cook, we'll laugh, we'll dance—all in this tiny space. Never needing an inch more of room because then we'd all be too far away.

Wandering from the kitchen, there's a dining table filled with candles that have been dripping for quite sometime. A bench and an electic collection of chairs, all found at some wonderful antique shop in town. During the summertime, we'll always dine outside. Dozens of pillows line the seats and I can tell you now, pillow fights will ensue as we argue over books we've read and movies we've seen.

The floors might be a bit uneven—historical charm, what can I say? Beams above, I'll remember the first time you hit your head on them. I'll be constantly apologizing for adoring a home too small for a man too tall.

The fireplace will hold memories of us making love on the floor, a fire diminishing and winter finally feeling warm. Mundane items within the living room, but of course none are mundane to us with memories like ours.

All the linens will be white, this is to remind us that we're living up in the clouds. The bedroom feels like heaven, simple and perfect. A dresser full of lingerie—mainly lace—I'm sure you've always wanted to make love with an angel. And you will, every day. With fresh flowers beside our bed—roses, lavender, irises—whatever is in season. Flowers are always the best decoration. But you'll know which my favorite is.

You'll touch me gently, never leaving a bruise, never leaving me cold. You'll whisper such sweet things—poetry. You'll whisper such naughty things—poetry. How you'll make promises you know you can keep.

You'll touch me tenderly as we make love. Your arms encompassing me as I straddle you. Shivers running through our bodies—our soul. How we'll look into each other's eyes feeling our entire world being destroyed and rebuilt. Hemingway was right after all.

Oh, a bathtub! We'll be reminded time and time again how rare that is, but you had done this just for me. Because despite everything you can give me, a star-filled night, cuddling with you in a warm bath will always be my favorite.

Home isn't just the cottage though. It's being bundled in kindness and respect, safely held against your chest. It's holding your hand when I'm feeling at my weakest *and* when I'm at my strongest. It's every thoughtful touch and tender look we exchange.

I forgot to tell you one of the best parts. We'll have places to write (I assume you write? Maybe or maybe not. Maybe you're a healer—someone who saves others, I hope). I'll prefer the petite room overlooking the garden. Religiously stationed there by the window, so when I'm drowning in a world of words, I can look up and out and remember to breathe again.

Sometimes we'll write together (again, assuming you write) in that comfortable silence. Other times we go to our separate locations at sunrise and meet again at sunset. Neither one of us being guilted, neither one of us afraid of space—we'll understand one another. We are after all, mirrors.

Then when we're too serious, eyebrows knitting, one of us will make a silly face or throw a paper airplane at the other (my apologies in advance for hitting you in the eye). Reminding one another that maybe we could use a break because maybe we need to interrupt our serious business with a kiss or a hug or both.

Feeling invincible, incredible, infinitely in love. We'll laugh one day at how long it took for us to get to know one another—to find one another in this world.

Outside there's a garden of roses and chamomile and irises and lavender. A little further away is the orchard of citrus trees. Planted with loving hands and endless dreams, we're always out here walking. We love walking hand in hand, pulse for pulse. The orange trees especially are our favorite...making love beneath them, counting stars, singing lullabies we've memorized by heart.

As time continues as it's meant to, I'll love watching you with her as you explain the miracle of oranges. Carrying her on your shoulders and walking down each row, you'll hand her a slice and she'll spit it out right away, claiming it tastes nothing like mama's mimosas (yes, that will be our child).

Watching her "boop" your nose and race down the orchard giggling, knowing her father will catch up easily, I'll smile. Then curse, then smile again as I look down at our son as he cradles his little baby hand around my finger and suckling on my breast.

At night, after we put the children to bed, I'll love feeling your hand on the small of my back, leading us back outside. Candles lit, two cups of tea waiting, homemade lemon bars and a mound of pillows and blankets for us to stargaze. I'll always be fascinated that I met someone just as romantic as me.

Sitting between your legs, feeling your lips brush affectionately across my bare shoulder—slowly working up towards my lips. I'll tell you, "you've done the un-thinkable, Darling. You've erased all the unwanted kisses that had once stained my skin. You're magic."

Then when we're too tired to keep our eyes open, you'll carry me to bed. Sliding in next to me and kissing me goodnight, you'll whisper, "its difficult to sleep when I'm living my dreams."

Smiling in the darkness, I'll reply, "I love you too."

This is home.
Not just the cottage,
Or the garden,
Or the orchard of citrus trees.
But you and them.
A family of our own...

...However, if all those things were
To disappear from my mind.
If my memories, hopes and dreams were
Wiped clean.
I'd remember you, always.
My first and last
Home.
My soulmate.

Your Equal,
LJ

Part Three

It's a scary word,
"depression".

A frightening
topic, "mental health".

But only because we labeled it that way.

She told me, "do you want to know the commonality of those who's spouses kill themselves?"

"I'm drunk enough—tell me." Taking another shot of pomegranate vodka, in the little pomegranate restaurant, her words hit me harder than the liquor, and I stilled.

She leaned back, lifting her chin, "a cold heart."

Unable to feel the burn, I replied, "is that why— is that why I always wanted to die? That certainly explains why."

"Yes, yes it does."

I still sleep in the same house I was raped in.

People tell me that I'm lucky to live where I live. Yet most days, I can't see it. I don't feel it.

I no longer sleep in the same bedroom, but below it. Below the mango-wood bedframe he caged me in, the memories ingrained in my head.

I wake up screaming sometimes, but the sounds are more like a whimper, a painful cry ringing in my ears until I awaken from the nightmares. In this house, I've lost my sanity with ghosts of my past and actual ghosts that find sleep paralysis amusing.

This house was built with pride and hard-earned money, with calloused hands and golden thread on the bones of Native Americans. I asked the owners once, "did you contact elders? Did you give these bones a proper burial? Did you bless this house?" No, because apparently their contractor "took care of it".

However, the bones of this place shake because of the hurricane I've become. The roof has been replaced twice because it can no longer contain the wind that was knocked out of me, the anger inside of me. Burst pipes—sad eyes—water flooding the floors and mold spreading to the walls. This is no longer home but a nightmare destination.

I have nowhere else to go though. So, I decorate the halls, the bedrooms and walls. I try to beautify the ugly. I try to take back what is mine, but all I feel is trapped in time.

Why did he have to desecrate more than one temple? Both of my sanctuaries? Was stealing my security not enough? No. He needed to take my safe space and turn it into a minefield.

I still sleep here. In this house that is a luxury to many and a nightmare, a burden, to me. Take the keys because maybe then the horror film that replays in my head when I step over the threshold will finally end.

This is not a sanctuary. This is a melting pot of bad memories I can't escape. Here, in the master bedroom, is where I was raped.

In the living room is where my best friend's husband died in her arms. In one of the guest rooms, I received the news that a loved one had been sent to a mental institution for trying to kill himself. In the other guest room, my mother found my ex's mistress' yoga pants…she thought they were mine.

The dining room is where I was told the news that a loved one had killed herself. The kitchen is where a monster said, "maybe you don't want to fuck me now, but in the future you will."

In the other bedroom, my mother told me that she was diagnosed with cancer. And just steps away in the hallway, is where she made jokes about me being raped.

My office turned bedroom, that's where I brought one man to bed. It's there that I learned he was turned on by my trauma. It's where I brought another man a couple of months later and he made a joke of my past, he laughed.

You see, in every room of this house, I have a memory I wish I could forget. But I relive it every single day. Tell me again, that this house is a fucking luxury.

Are you tired of reading
my poems about
Rape?

Is it bothering you
that there are too many poems
on the topic of
Rape?

If it had only happened once
or twice
or even three times,
I would only write
one or
two or
three
poems then.

Are you tired of reading
my poems about
Rape?

Yeah...?

Well, I was tired
of being
Raped.

A conversation with my ex.

"Do you want to know why I feel like you're being selfish?" he spoke angrily, crossing his arms against his chest.

1) "I've had to move a lot..."
...despite it being to nice places.

2) "I had to give up my friends..."
...despite them being the ones I was cheating on you with.

3) "I supported you when you quit your job..."
...but didn't stop buying alcohol and I made you pay me $3000 to change my attitude.

4) "I had to take on the financial burden..."
...even though I make three times as much as you when you did have a job.

5) "I don't like asking our parents for money..."
...though I happily accepted all of YOUR family's money.

6) "Sexsomnia runs in my family. My father does it to my mom. My brothers do it to their wives. It's hereditary..."
...I once made the mistake of admitting that I was awake every time...whoops.

8) "It's your fault. You never asked me to get help for Sexsomnia...."
...even though I chose not to go.

9) "You don't want to fuck me now, but you will later..."
...I'll just wait till your asleep again.

10) "So, you don't want to have sex with me which means there must be someone else..."
...I bet it's that Poet you saw perform. You're fucking him, aren't you?

11) "I can help you work through it. That you don't want anyone touching you. I can fix you..."
...even though I was the one who broke you.

12) "You have a terrible way of cutting people off..."
...don't you dare cut me off too.

13) "I'm your partner. This is not what you do to your partner..."
...this is so unfair.

14) "I dealt with you family drama. Your crazy aunt and grandma. I never would have helped you guys if I knew you were going to divorce me..."
...I never liked your family but I loved the money, the free vacations and the gifts.

15) "I want to stay if you need anything. I can be here for you as you work through whatever the hell is wrong with you..."
...again, I'm not the one to blame when you're sleeping half-naked beside me at night.

16) "I don't need thereapy. You do."
...you're damaged goods, you're broken.

Dear Ares,

You don't deserve a letter from me.

But here I am, writing you one anyways. It's here. The day I've been waiting for, crying for, begging for. Our ending official; signed and stamped—approved.

You don't deserve a letter from me.

But I wanted to write you. There will never be a day, where my pen doesn't tell my truth. May my words burn into your skin as you carved your legacy into my bones. May they choke the air from your lungs as you drown in the permanent reverie of us. May the stars whisper in your ears, touching you with the madness you once so lovingly exposed me to.

It took me eight years to leave you. I have stifled my poetry for eight years, unable to get the words down on paper. Instead I took a liking to novels; I never told you, but I found you in every line. You were the villain in every piece of fiction I wrote.

I knew it was you, but I couldn't accept it. At the time, I wasn't ready to. I accept that it wasn't all your fault. I let you treat me as badly as you did. I never knew any better, but now I do.

There's no excuse for your actions, there's no blame to be pushed onto others either—even if that's what gods do best. Rape isn't hereditary. Gaslighting isn't pleasant conversation. Violence isn't love.

I gave you my youth. I gave you everything and still, you wanted more, and soon I wasn't enough to satisfy your hunger—to end the war.

It's taken me six months to realize that the love I had for you wasn't really love. It was fear. I was terrified. Yet it didn't matter how many times I expressed this to my own family, you were perfect to them.

I've learned that monsters find other monsters beautiful. You see, it's reflections that we fall in love with. But I was never in love with you—I feared you. I feared life without you. I feared loneliness.

I was taught to.

I had grown up with my mother's favorite fairytale, Beauty and the Beast. Constantly being told that beasts are princes in hiding. That if you're lucky, they'll find you pretty enough to marry you, to save you.

"Plus, imagine a library like that to have at your disposal," she'd say, laughing.

I was never taught what Stockholm Syndrome, Complex Post-Traumatic Stress Disorder, Anxiety or High-Functioning Depression was until I was told that I had each one. No one knew of my eating disorders until one woman caught me. No one in my life knew. Not even you.

You had this beautiful way of convincing me that I was crazy though. That every reaction, no matter how big or small was insane. You would even make jokes about

it, somehow that was funny to you. But when I would question you, when something wasn't right, you would tell me I was hungry, I was tired, I was pms-ing. Every excuse to silence my voice until it was gone.

But it wasn't just you, it was my family too. When I told them all you did to me, when I told them the truth. They didn't believe me at first because I had looked so happy with you. I guess the acting lessons paid off when I was a kid (it was cheaper than therapy, my parents always said).

Maybe that will bring you some comfort, you weren't the only monster in my life. It took me time to realize that I had only "loved" you out of fear and before I was frightened of you, I had "loved" you to the capacity that I could. You didn't deserve even the scraps that I had for you. You certainly don't deserve the love that I am capable of now.

I still think of the day that changed my life, the stranger who reminded me that I didn't need a prince to be saved—I just needed my pen, my sword. One that had always been in my hand, but I was put under a spell and forgotten all about it until he woke me up. He reminded me that I was a Poet, not a princess; a Queen with a bigger destiny.

He was right. I never needed someone to save me. I never will again.

Not that you need to know, but I had never seen him before, and I only saw him once after. You were convinced I was having an affair with him. When you asked me, several times I might add, all I could do was laugh. The man who cheated on me more than once was worried that I was having an affair with someone. You were concerned that I was leaving you for him. No, I'm not you.

I said, "I'm not you."

You took the books off my shelf and you looked at them with disgust. So fragile in your claws. I wasn't sure what you were meaning to do, but I remember your words. Ones I'll never repeat.

When you had shut the door, I ran to them, brushing my fingertips along the delicate spines. I wondered what else you were going to take from me. My body, my sanity, my safety—and now you would take my books too? How dare you. As if the rest wasn't enough, you would take what little left I truly loved.

Ten days. I lasted only ten days after my awakening. I calmly told you, "I want a divorce." You got up and slammed the door shut. Opening another to slam that one shut too, the entire house shaking as you screamed and cried in the other room.

Waiting for you, my back bracing against the cold wall with the dog in my lap, I panicked. I froze. Then you opened the door and sat silently in your rage until you mustered, "what am I supposed to do now?"

Prior to that moment, I didn't realize how often you took advantage of me. "What am I supposed to do now?" Imagine hearing that, of only being your "soulmate" because you were serviceable.

I'm struggling to not let the world see all the colors you are. Red and black and grey— you are every shade of pain.

There are eight years' worth of stories that you can't hide from...and neither can I. You didn't break my heart; you broke my fucking wings. And I let you.

I didn't and still don't hate you. The last six months of untangling the knots of my past and healing, I realized I didn't really hate myself either. The hardest part of this time alone hasn't been trying to figure out how to forgive you, but how to forgive myself. How and why did I convince myself into believing you, the god of war in human form, could ever love and be loved?

For years, for my entire life, I was numb. I did that to survive. That was prior to knowing of your existence. That is not on you and I will never blame you for making me numb. I've done a lot of things to survive, many of which I'm not proud of.

Surrounded and suffocated in toxicity throughout my life, I was not a good human being at one point either. I will not pretend that I have always had a kind heart. I will not pretend that I am a saint without a sinner's past.

However, I am not you.

Today the divorce is final. Today I am swimming to the surface, towards the light.

In this time of healing, I was always swimming to someone. I was always wanting a savior. Whether it be my friends, my therapist or the fantasy I had created in my head with that man who I anchored all my hope to. I swam towards the sun, but she needed her rest too. I swam towards the moon, but he was just as broken as me—riddled with holes like me.

So, now I swim towards the stars. To the pieces of me; home. I'm not going to survive anymore; I'm going to live.

I'm going to swim.

I want you to never forget that. You were not a good man. You were not a good husband. However, it doesn't mean you can't be in the future to yourself and to someone else. That is my hope for you. That you grow from this experience.

I have.

I will not let you ruin my future with another. I will not burden them with trust issues, with night terrors, with the pieces of me—No. I will not let you dictate how I love, who I love and who loves me. I most certainly will not settle again.

No. I will heal. I am healing.

I'm not going to survive anymore; I'm going to live. I'm going to swim.

It's not only you I forgive, but me too.

To an ending that's always been written in the stars, I hope you find peace one day. I hope you find love again.

I hope I broke you, so you could be remade into a better man.

LJ

She said that she accepted the fact that she would one day kill herself.

There wasn't a time or a destination,
just the knowledge—the acceptance.
She said that she could be old and wrinkly,
decades before she tries again.
There wasn't a time or a destination,
just the knowledge—her hope.

I thought my reaction (and I think she thought the same) would be of horror.
Instead it was understanding.
I gave her a piece of Hope, broken off from my own.
I told her to keep it with her,
because her Pain needs a friend and
my Hope needs one too.

Dear Soulmate,

I nearly died this year, many times. In a way I think I did.

Sometimes, it's when I'm having a really bad day and I'm on the corner waiting to cross the street towards my car. The sadness keeps building, creating a pressure in my chest until all I want to do is scream but silence has choked the sounds from me.

So, I debate it. One foot, that's all it takes. One foot up, one step down and I'm directly in oncoming traffic.

There was one time that I remained on the very edge. The red paint looking brighter against my black leather boots. The tips of my toes moving closer and closer. Then I saw the person in the car driving by, mindless of me, but she had a family.

This stranger had an entire life that I was about to ruin because I could no longer see the light. I was going to steal someone else's light by stepping down. I was going to cause trauma, pain...

So, I raised my foot and I took a step back. My heart beating erratically, tears building in my eyes. "Think of them," I whispered to myself. "Your soulmate, your future children. Think of the strangers who would be impacted by the loss of you." Because no matter what, no matter who, we are all touched by the loss of another being. We're all connect-ed, you see.

There were many times before this that I headed towards the cliffs and thought, "what if...?" From a young age, I had always fantasized about falling off the edge. To finally be free.

I made the mistake of telling people this. Of one person in particular, who used it against me. Here's the poem I wrote to better explain what happened:

I wanted to fall off cliffs
my entire childhood and
adolescence.
To escape
that's what I really wanted.

Then I met someone
who I thought would
keep me safe.
I opened up to him,
revealing my past,
giving in to vulnerability.
I told him of all the
pain I was harboring.
Of the abuse I couldn't
shed.

I was honest when I said
I would stare out every window
to study the landscape,
wishing to fall
back first
with my arms out,
heart open,
for just a moment
to get away.

Despite knowing this about me,
he proposed.
On the edge
of a cliff.

No wonder I was numb.
No wonder I stayed silent.
Always trapped in a vicious
cycle of abuse.
They don't tell you
that not every day is violent.

"Are you going to say anything?"
He guilted me into saying
yes,
because at the time I didn't know
how to say
no.
At the time, it was either yes or
jump.
I didn't want to hurt him,
I didn't want to hurt anyone.
Somehow that meant it was better to
hurt myself.

...there's more but you'll have to read that some other time.

I'm not saying any of this to hurt you. I'm saying this, so you understand that I didn't do it. I couldn't go through with it.

It's not out of fear of dying that I don't jump, it's fear of never meeting you and being with you. Of never having adventures and children with you. Of never getting to love you in all the ways you deserve. It's the fear of never having the life that I've always wanted, with you.

Recently I ran away to the Grand Canyon. I let a boy drive me mad along with the building pressure of everything else in my life. Next to the railing there was a picture of a man smiling and votive candles decorating the ground.

"Do you think he jumped?" she asked me.

"That or he fell," I replied, both of us knowing the truth.

"How stupid—how stupid to kill yourself," she said. "What a waste."

Biting my lower lip, I wanted to shake her, to yell at her so loudly that my voice echoed across the canyon but instead all I said was, "it's a beautiful place to die..."

I shook my head; she didn't understand. Not the kind of sadness that eats you away inside until you're a void of darkness. Until you've lost your light, your sight. Until you think jumping will end the pain instead of spreading it.

She continued her rant as she looked out to the horizon of red cliffs and I imagined climbing over the edge and letting go of the railing. Of hearing her scream, reaching out for me but being too late.

Fall.

Fall.

Falling.

How easy this has been to imagine such things my entire life. How it's deeply rooted in what little memories I have.

Instead I willed myself from the weathered bars and whispered, "is this why I chose the Grand Canyon to runaway to?"

Yes.

I made it home with a fucked up car, a friendship in ruins and the realization of what I had done by running away. How I let many people down by leaving without a word. How I hurt many and changed my entire future.

I learned my lesson, is what I'm trying to say.

Abandonment is cruel no matter who you unknowingly do it to. I learned my lesson. I promise I won't run, even if life crushes down on my lungs again.

If you couldn't figure it out by now, I have High-Functioning Depression. I have many things that torment me, that pull me down easily. But I'm trying my hardest to explore it so I can defeat it.

I'm trying to understand this gift of cruelty. Why was I given so much darkness? Why has my life been filled with it? How am I supposed to show anyone how to embrace it so they can let it go?

See, big questions that I don't have the answers for. I'm still learning them on my own. I'm saying...

I can't promise you happy times for the rest of your life, but I can promise you an adventure. I can promise you a story that's never been told. I can promise you a love you've never experienced before.

I can't promise the weight of the world will be off your shoulders, but I can promise the weight will be shared. I can promise you love letters. I can promise you poems and breakfast in bed. A damn good cup of tea and singing forever off-key. I can promise you will have my heart for as long as you nurture it.

I can promise you an incredible love story.

Your Equal,
LJ

Dear Soulmate,

I know if we had met as children,
you would have taken my hand
and brought me to a treehouse
far up in the sky,
far away from the monsters in our lives.
Guarding the window
with a trusty slingshot,
your loyalty for me unwavering.
I know you would have been thoughtful
and brought my teddy bear
and a bag of squished lemon bars.
And even when your eyes would tire,
I know you would have sat beside me
refusing to sleep
making sure the beasts
wouldn't infiltrate my dreams.
I would have thanked you
a thousand times but anyone else
would have only heard silence.
I would have held you and told you
it's okay to cry, tears are not
the ones that are violent.
If we had met as children,
we would have kept one another safe.
So, in the next life, I'll find you
sooner than we have in the past.
I'll find you
and we'll fly away—
Free.

Your Equal,
LJ

I hope one day you feel safe
enough to tell me of
your demons.

I promise to only listen,
and hold your hand
when you need it.

You'll come home one day,
hanging your head,
struggling to take a breath.
The entire day an absolute mess,
causing your shoulders to curve forward,
guarding your heart.

Then you'll hear my favorite song
about stargazing,
of always finding hope in love.
Following the music to our bathing room,
you'll see dozens of
candles lit on the counter
and milky water sprinkled with
pink and white rose petals.

My tired eyes closed,
a soft smile on my lips.
Coming to the edge of the bath,
you'll take a seat beside me.
Remaining quiet, thoughtful,
wanting me to have a moment of peace.
I'll peek one eye open, then the other.
My smile expanding, my heart racing.

Except I'll notice your pain right away,
the sadness you carry.
At first the roses will cling
to every curve of my body
as I rise just enough to meet your eyes.

But now they're too heavy,
the soaked petals
ever so slowly dripping off my breasts
towards the rising steam between us.
Your tender eyes lingering,
the room tightening with desire.
Your jaw loosening,
words wanting to flow out but
somehow, you're unable to make a sound.

Wrapping my loving arms around you,
embracing you,
I'll feel your head lean against mine.
I'll silently promise
to evict the demons from your mind
every day for the rest of my life.

That's when I'll kiss you,
distract you,
before pulling you in.

Because this is what lovers do,
reminding one another how to breathe
when the entire world
feels like it's going to end.

let me show you
how beautiful
your darkness
can be.

i'll weave stories
of your past
with smiles
of our future.

i'll kiss the stardust
off your lips,
then run my fingers through your hair,
murmuring in your ear,
"darling, you have nothing to fear."

If the moon were to fall,
I'd catch him.

With my palms woven of gold and fire,
I'd mend him.

Pressing my warm lips to his,
I'd free him.

For we are each other's
Reflection,

Separated by
A cosmic sea.

Love Lesson #2:

I wanted to give you a bit of guidance and perhaps some hope as you navigate through this life. I looked at photos of me ten years ago, age seventeen. Depressed, anxious, suicidal—desperately wanting to escape my life.

I grew up being told that I wasn't beautiful enough, that I wasn't going to succeed, and my expectations in life were too high. So, I settled. I believed every discouraging, cruel word that was ever said to me because I had loved those who spoke the venomous words, I had loved them all so deeply.

I settled. Every day I felt myself fading more and more. I still remember the day when I woke up and went to the mirror like I had every morning but this time I couldn't smile anymore. I couldn't fake it. My body was giving up, unable to keep up with appearances.

Glancing through some of these old photos I found, I recognize that I only recently started to smile. Actually smile. It has taken twenty-seven years to do that. To be happy.

It hurts my heart, it hurts so much to realize I had surrounded myself with people who genuinely thought I was happy and felt shocked and betrayed when I said I wasn't. Your friends, your pack, your village—whatever you want to call these loved ones—impact you in so many ways. They are your support system when you can't support yourself.

But what happens when you have no one? Well, you're never truly alone because there's an entire world of people who feel the same way you do. You may be alone in your room, but you're not alone in this world.

After my divorce I was told that I better find another man quickly. I'm closer to thirty than not and I still want children. "Eventually you'll lose your looks, you'll gain weight and having children after thirty will ruin your body either way and you won't bounce back." They continued to tell me how when you're thirty the pool of men decreases significantly. By fifty, you better know how to cook because your looks won't keep them. Many more awful things were said to me—have been said to me—and I'd rather not relive it but I think you get the picture.

You can imagine that as a woman fighting multiple eating disorders, how painful that is to hear. To be told yet again that I wasn't good enough for the type of man I wanted to wait for, for a soulmate. That I needed to settle. Again. Settle so I can have children, settle so I can remain beautiful because, "children suck the youth from your bones and you'll never get it back if you continue to wait."

It's taken me a very long time to understand that who you surround yourself with impacts your health—mentally, physically, spiritually and emotionally. Do not surround yourself with people who do not have the capacity to love you unconditionally. It's not worth being in a full room and feeling lonely. It's not worth losing yourself to please them.

My lessons for the day are below. I hope they help. I hope you find some peace in this scattered bit of writing.

1) There are so many people who want to break you because they need your light to survive. They see how bright you can shine without them. Sometimes these people are the closest ones to you. You might not want to be alone, it's a scary thing at first, but loneliness is much kinder than you think.

2) You fixate on your looks because you've been told your entire life that beauty is what grants you true love. I had a sun freckle appear just below my left eye. I had a breakdown over it. A complete falling apart because I was told from a very young age that if I didn't protect my skin, if I didn't have beautiful skin, no one would fall in love with me because I would look too old. Heaven forbid, I ever age. It was only a freckle. And it's pretty cute, like an isolated star just below my eye.

There is so much more to you than your looks. You have a mind, a heart and a soul. You're made of the stars and yet people are so worried about their reflection. Never were they taught that your light comes from within. These photos, to me, I look older in them than I do now. It saddens me that I had listened, that I had twisted their words in my mind until I saw someone else. A body that wasn't mine. I let them distort my image by listening to their hurtful comments. I let myself binge and starve and continue like this for a decade. If only I had listened to myself a bit closer, the little rebel voice that told me I was beautiful. Maybe then I would have had a fighting chance. Be kind, be a rebel.

You can see my smile wasn't really a smile, even when I tried. Every photo I found I looked engulfed in pain. I was a lonely kid, far too broken to realize it then. However, even on my lowest days that I sometimes still experience, I always remember that if I want to, I can smile now. I can smile and mean it.

3) I have spent all day crying in bed unable to get out because the weight of the world was pressing on my back. You're struggling to get to your knees and can barely push yourself off the mattress, crying hysterically because you lack control over your body and you're fucking exhausted.

I understand exactly why you don't want to breathe, to move forward. To move at all. I know what it's like to stare in the mirror and struggle to put on that familiar mask. I get it. It's really, really hard but you will get through this time of hopelessness. You will.

4) Your trauma is your own. Do not compare it to others because that's not only stealing someone's resilience but stealing yours too.

I hope you remember to keep healing, to keep fighting. You will heal yourself whole, alone or with your people. You're going to make it through this insanely difficult time and one day, I promise you, one day you're going to smile for real. You'll shine.

I want you to put on your crown. It's time to grow and tell your monsters to back off because you're fucking busy.

You have healing that needs to be done, you have dreams that need to be conquered.

You got this.

Yes, you do.

Yes, you can.

You got this.

I wish you would think of
yourself as the sky and
your scars as the clouds.

The sky's
beauty
is enhanced
by clouds.

CRY IN MY ARMS,

FEEL THE DARKNESS CREEP IN.

JUST KNOW I'LL BE HERE,

WHEN YOU'RE READY

TO SHINE AGAIN.

You have to think about the future in light. You have to dream even when all you see is darkness. I dream hoping to find peace because one day I will. Sometimes this is what I see.

One day,
I'll put on your large, wool socks.
Softly kiss you forehead then neck,
I'll hear you sleepily moan, "don't go,"
as I sneak out of our cozy bed.
Waking up the children,
I'll tell them its time to cook up a feast.
They'll rush outside into the garden,
making you a mud pie,
and hoping you'll eat it.
They're so clever,
because mud and chocolate look so alike.
I won't stop them from asking,
always finding it humorous to watch you,
"magically" devour this thing.
Their laughter and playful screams will wake you,
and when you come from our room,
hair a bit tousled, our necklace secure on your chest.
I'll notice the smile you give and the love in your eyes.
Because when you see Us,
the family you've always dreamed of
playing outside,
you'll remember why you do what you do.
Why you choose to wake up
why you choose to go to work,
why you love coming home safely.

Dream, Darling.
Because one day, you'll find me.
One day, this will be our reality.

I am hopeful

that the day we find each other,

the stars will align,

connecting us two with an

infinite string of light.

Part four

I know I've discussed High-Functioning Depression, Complex PTSD, Anxiety, Eating Disorders, Rape, Divorce, etc. But I haven't told you everything about me. I know, strange to think there are stories that will never be written for anyone's eyes to read.

There is one I want to tell you though. Her memory should be in these pages. My god, she deserves more than this, she deserves a fucking monument.

She would agree.

She's my best friend. Was.

Her name was Mara.

Dear Soulmate,

I probably haven't told you about my best friend at length. I'm sure you will have asked who my best friend is that I've mentioned in passing but never in detail. It's not always because I don't want to discuss her, it's just I don't know where to possibly begin. Maybe I'll start backwards.

She died.

Two years ago, October 30th. She was sick for a long time, but I didn't believe that her illness was the culprit, I believed it was sadness. I believe she was ready for me to move on and for her to be with her soulmate once again.

He died too.

In her arms, in the early hours before the sun ascended over the horizon. I remember the call I received before heading into work. I sank to the floor as she screamed, "he's dead!"

I remember the hysteria, our hearts breaking and our tears crashing. Somehow the world had silenced itself just for us. Maybe that's why it sounded so loud, or maybe we both were just screaming without realizing. I thought I'd never feel pain like that again, losing him—losing a part of her. But I did. Again, and again, I lost so many people I loved, I love.

Every day for as long as I could, I called her. I listened until she couldn't speak. Or when she never started to say anything, I would tell her about my day. Even if it was just to discuss the weather, I'd always call her. When she had no words, I spoke for her. When she was too tired, I did my best to comfort her. I tried but distance doesn't heal you, no matter if it's time or mileage. Sometimes, you're just fucking broken until

you heal on your own.

Then I ran. I got the call that she was sick, in the hospital. I ran. Uprooting without hesitation, this was my best friend. She needed me and I needed her. Why had I waited for an excuse to be with her? I don't know. I feared many things until fear could no longer control me.

There were days that we loathed one another, both in too much pain to see or speak clearly. I regret saying some things to her—I just didn't understand. I know she felt the same. It was in how we looked at each other, both angry at the universe and unsure how to resolve such feelings. But never, never did we not love one another.

I lost her. Every fight, every disagreement faded from my memory. I was at work in my cubicle, thinking about her and how much time we had left. That maybe there was a God after all, and I just needed to pray a little harder for my wish to come true.

I made it in time to hold her hand and watch her die. Thirty minutes. For thirty minutes, I held onto her and waited as she moved forward without me. The warmth fading from her palm, my pain escalating into numbness. I watched her die.

At this point, after losing so many people I loved, I should have been okay. I wasn't. Because the truth is, it never gets easier, no matter how long you know death is coming. When she died, I let go of her cold hand and I cried because I knew this world had lost the sun and what is the moon's reflection without the sun?

I thought, it's been almost two years, I should be okay by now. I'm not. It never gets easier; the pain doesn't dull. Whatever they tell you, that time heals you, it's a lie. Time doesn't heal your pain; you just grow stronger in carrying it with you.

So, when you ask about certain photos or the worn out covers of naughty romances I keep in my library—it's her. Even the painting upstairs, I would run back into a fire for. Her.

You want to know about her? I'll tell you.

She once wanted to join the Airforce to jump out of airplanes, but her brother locked her in her room until she changed her mind. She could wiggle her eyebrows perfectly. She had the best damn eyebrows.

Dr. Pepper was the only doctor she liked. She loved her husband more than there are grains of sand on Mars and Earth and every planet in this universe and the next. *Friends*, that was our show.

She had the best giggle, but it would only come out if you could make her laugh...or give her wine. Doris Day. Any movie, any song. They were ours. Eggs over-easy with salt. And how could one forget the bacon?

"Be Cool" was her catchphrase. She pretended to be napping to avoid phone calls and texts. She lived in Italy, France and Serbia too. She was fearless, adventurous—a woman every woman longs to be.

She accidentally painted the windows shut because she thought the trim needed "sprucing". I'm still not so sure either of us knew the definition of sprucing at the time. And some of the windows still don't open because of her great idea.

She loved me more than I was able to love myself. She showed me I was worth loving. She thought skin cancer was bullshit despite having it...twice. She was the definition of fearless.

We would always have something sweet when we went to the mausoleum to see her husband. Always needing chocolate to chase the tears away.

My best friend knew me better than I knew myself. She warned me about my alcoholic ex. She warned me about my father. She warned me about myself. And still, when I self-destructed, she showed up.

But she died.

That's why I can't speak of her. Not only because the loss of her hurts so much still, but because I don't know how to tell you about her without falling apart and having to pick up my pieces again.

"She died," I'll reply when you ask of her. And when you want to know more, I'll say, "she was the sun, and I was the moon. And together, we shined."

Your Equal,
LJ

Dear Best Friend,

This year will be two years since I held your hand and watched you die. I never thought you would go. I thought you to be invincible. I thought you to be an immortal goddess of some sort.

I thought wrong.

You know I remember receiving the call that you were in the hospital. I remember my entire world crashing in that one moment...again. I was used to crushing phone calls though. He died in her arms, they said. She hung herself, they said. He used a gun—but he's still alive, they said.

It wasn't the first time you were in the hospital, but it was the last. I remember trying my hardest to put on a brave face as I entered the room to, "be cool," like you always said. I remember seeing you drained of color, your head shaved and stiches where they took out pieces of your skull.

You were fighting to stay alive just a little longer, to let me say goodbye. I remember wishing you could hear my silent pleas. Please don't leave me, not with them. Please don't leave me, I'm not ready yet. You could always hear my silence; I sometimes wonder if in that moment, you did.

I held your hand and watched you die, 4:36 pm, October 30th. I knew you hated it when people ruined holidays, that's why you left sooner. I'm still not so sure you considered Halloween much of a holiday. I'm not so sure you enjoyed any holidays after he died in your arms. I'm not so sure I did either.

But we tried, didn't we?

We put up the Christmas tree, we decorated it together. We thought somehow that would make us feel better. It wasn't until New Years that I think we began to smile as best we could. I think the sangria truly helped. I think being drunk cures a lot until it doesn't.

You were right when you said he was an alcoholic by the way, when you whispered it to me in the laundry room before we moved here. You were right when you said nothing but gave me that look, that look that said everything after you saw the ring on my finger. After I told you where he proposed.

You were right when you questioned why I was wearing black on my wedding day, and I was right when I questioned you on why you chose dark blue. Why neither of us could truly smile when he was in the room.

I remember for every therapy appointment I took you to, I would get us In-N-Out and Dr. Pepper and we'd sit in the car by the ocean. The sun shining on us, our sunglasses reflecting massive burgers and red palm trees. How happy you were to eat. How happy you were to just be. Fuck, you hated doctors more than anything, but you loved Dr. Pepper. You loved being snarky about my inability to eat meat, dairy—everything.

I still remember watching *Friends* with you every night for months because it was a show that finally made us laugh again. I remember sitting out in the garden and we would just read and read and read. You had your book, I had mine and we always had a plate of fruit—sliced oranges, our favorite.

You were always into the naughty romances; you would kill me now for un-veiling your secret if you hadn't died. I mainly read fantasy then (I had given up poetry for some time; it made me feel too much and you know how I felt about feeling, how I've always felt too much) not knowing at the time I was trying to escape everything. We both were, weren't we? Trying to escape the world of monsters that hurt us, unable to find the princes to save us.

Somedays I think I needed you more than you needed me. Even after he was gone, when I called you every single day before moving in with you. You could always carry yourself with so much strength and grace, even when you were crumbling. I was just crumbling.

There was that one time when you fell, and I couldn't get you back up again. I was too weak to lift myself off the ground, let alone a beautiful woman with wings. To commemorate our failure, of me calling the neighbors for help, we took selfies shamelessly—hysterically laughing at how ridiculous we were. How sometimes it's fun to fall and not get back up again. I still look at them on my phone, every single one of them.

You were and forever are my hero. And even though you had to go, to embark on a new adventure, I hope you always know how much I love you. That I have missed you every day, more and more for the last two years.

I imagine when I grow old, if I'm lucky to do so, I imagine what that's like with-out you. To grow old without my best friend. It doesn't really make sense—a future without you. But I'll have to learn, I'll have to be brave, I guess.

I wish you were here to see how far I've come though. That I left him, I did it.

That I lost so much in the process, including all the friends you always disliked (yes, you were right), but I gained back years of my life. I gave him everything except the pets and my books (the ones he almost took).

Even though the house is empty, somehow that's better than broken.

I know now, if you hadn't gone first then I'm positive it would have been me instead. That I only held on because you did. Maybe we held on until one of us couldn't. Maybe you knew my dreams were too big to pass up and you were done with me making little of them.

Or maybe you lost your soulmate and you didn't see the point in a life without him. Maybe I didn't understand that kind of love, but I understand the hope for it. I understand losing that hope would kill me too.

I still remember the funeral. How the people who didn't bother with you stood up and told everyone how much they loved you. I thought I heard your snort from heaven.

I remember being so goddamn angry that I drowned in silence, grinding my teeth, staring at the carpet and wondering what the fuck was I there for. You were dead, a part of me had died with you. This wasn't a celebration of life; this was court, this was people pleading guilty of their sins. This was the sinners waiting for a standing ovation.

I'm still putting myself back together, but the process has been wonderful. I never knew loneliness could be so good for me. I'm still putting myself back together, but I think you would like who I've become. The woman who I was always meant to be.

You know one day. I'm going to meet someone incredibly special and I'm going to have to figure out how to tell him about you without crying. I hope that I'll just be able to look at him without saying a word and let him see how beautiful you were and are to me. Maybe somehow that will lessen the hurt.

I wish you could meet him, whoever he is, but maybe you have. Haunting him all this time to see if he was worthy of me or not, I wouldn't be surprised if you did. The idea of you haunting my soulmate makes me laugh.

I promise at my next wedding I won't wear dark blue or black. I promise since you can't walk me down the aisle, that your picture will be close to my heart. I promise it'll be in Italy and there will be so much damn wine and food and laughter and dancing that I'll hear your whistle from heaven. That I'll see your face in the clouds, your eyebrows wiggling with delight.

I promise next time, I'll marry the right guy, my soulmate. I promise I'll listen to my gut.

I still remember everything, you know. Too scared to write it down, to think it out loud. But our memories are there, locked inside my heart. Perhaps that's why my chest hurts so much lately, it's tired of being an album for our memories.

You know one day, I'm going to have the courage to tell the world our story but until then, I'll keep your memories safe within. It's been almost two years since I held your hand and watched you die. And every day I miss you more and more.

I'm going to miss you for the rest of my life.

I hope you know that every day I think how lucky I am to have known a soul like you before you left this world. You were and will forever be one of the good ones. Until we meet again under a different sky.

Love you always,
LJ

After she died, everything fell apart. My entire life. Apparently that can happen more than once. And more times in one year than I thought possible.

Then I began to pick up my pieces in therapy. I was trying to live again. I saw this ad for an event and I needed to go. Like the Universe was telling me, "this is it."

That's when I saw you. And it freaked me the fuck out.

"Are you okay?" I asked him.

"Hm?"

"I just, I get it. I made it just in time to watch my best friend die. I know what it's like. That's all."

"Oh my god..." he replied as his arms reached out for me.

Finally. Someone understands me.

can you guess what happened next?

do you remember what you wrote?

i guess they'll never know
because words
of smoke and mirrors
only come alive in the shadows.

i know what you said,
what you wrote.
turn to the previous pages,
its in there.

the flower that is
brave.

the flower that is alone,
alone for miles,
never forgetting to face
the sun.

I hope you're safe.

I hope you're happy.

I hope you're healthy.

I hope you're loved entirely.

These were messages for you, buried in my timeline. I saw what you wrote too. I thought I was insane, descending further into madness. First driven closer by loneliness, then by you.

How could you? Why would you?

I'm the one who's fucked up already. I thought you knew.

You're somewhere between reachable and

Unobtainable

Like my shadow in the moonlight

I WROTE THAT FOR YOU.

the man who hides in the shadows,
only illuminates
beneath silver moonlight.

he doesn't want to embrace the sun,
he wants to reflect it.
he wants to steal it's light,
to make it his own.
why do you think he never helps
the little ones?

he wants to fade away into the darkness,
so consequences cannot
find their home.
staring at the words in black,
stained on white,
i grinded my teeth as tears swelled into my eyes.

"there's no point in scolding a sinner," she said.
"one day, he'll remember your name."

i remained silent as i watched a blurry smile form on her lips.

"don't you know? queens live forever, LJ."

AND THIS ONE TOO.

I WANT YOU

TO REMEMBER

THIS DAY.

THE DAY

YOU WERE

PUT IN YOUR

PLACE.

i am not another muse.
i'm the woman you lose your heart to.
i'm the woman who holds your love safely
in the palms of her hands.
i'm the woman you're not madly in love
with, but deeply.
so deep, you've carved your way through
the universe, still not even halfway to the
end.

the one you're excited to bring home.
i'm the woman you marry.
the woman you have children with.
the one you grow old with.
the one you cry to.
the one you read to.
the one you watch bathe
in the silver sea.
the one who ruins your poetry
and smiles.

i am the only one except...

...i've learned
i'm merely the flower
you picked
and pulled apart
for your art.
i thought i was crazy, you know.
this back and forth.
i didn't think you'd be this cruel.
how many women have you done this to?
how many women are you doing this to?

i am not another muse,
another "one" for you to use.
i'm the woman who shines
when she blooms.
i'm the rose
covered in thorns.
i'm the woman
you're still not ready for.

i am not another muse,
i'm a fucking poet.
and you're just a
coward with a pen.

the end.

you inspired me too, you know?
these poems,
they're all for you.
i saw me in your words too,
ones i would only know.
was i imagining this?

i wasn't.
you were leading me on,
you were abusing my infatuation for love.
i was confusing my infatuation for love.

eros, beautiful and broken,
but your beauty began to fade
the longer you kept this up.
the longer you were gaslighting,
hiding.

i wrote this for you
but it's time that i take these words,
my words,
back.

you inspired me too, you know?
and the idea, the hope for you,
you took that away from me.
thank you.

now you can rest knowing,
that for once in your life,
the broken flower
bloomed her brightest,
but her light is too
bright for you.

To a Poet,

I'm not your
fucking muse.

The problem is...

...we'd end up just like my parents.

Both in the same career field, but you'll always get more recognition because you're a man, not because your work is better. The worst part is, you'll know this too but not do a damn thing about it.

You'll be just like my father, the alcoholic, the womanizer with a big heart for "fixing" broken women. It's called knight in shining armor syndrome. At first, you'd love the idea of me then possibly love me for me until you see another brown-haired beauty and you'd leave. Always coming back in the morning but I'd know where you were, "finding your creativity, your inspiration" for your poetry. Another muse for your records.

It'll crush me and I'll push you away. I'll sink as I think about all the times you showed me how much you loved me. Which isn't very much, not even a little, not even at all. Instead of leaving, I'll forget my self-worth, I'll fight for *us* to work. One night, it'll seem like all the cracks in our foundation are filled with gold. We'll make love, we'll create new life. Together.

Our first year will be beautiful, the family we've both always wanted. That is until the tours begin and night after night, you'll meet hoards of women who want to be saved, who want you as their knight in silver armor. As you gain more muses, you'll begin to resent me and the ring on your finger until you stop wearing it one night. You'll claim your finger is too big for such a tiny ring, "it hurts".

You'll come home eventually, with new contacts in your phone. disregarding me and going straight for our daughter. You'll be a good father for a time. Except the drinking will get worse and the women more frequent until it's only me and our daughter home alone together. She'll begin to ask questions about her father and somehow, I'll have to carefully craft my sentences to no longer show my pain. I do this in hopes that our daughter doesn't see you for the monster you are.

At this point in our timeline, we no longer sleep in the same bed. You'll claim back problems but really it's your fucking guilt that's crippling you. So, you drink and write and write and drink every night until you fall asleep. But one goddamn day, I'll put my foot down and say, "us or booze. You choose."

Nope, this isn't where our story ends...surprisingly.

I'll take a job 2,000 miles away and hope that you'll follow us. You'll want to prove yourself to us. You can be a better husband and a better father. But you don't, you never will. Instead you take our daughter on fancy apologetic vacations yet miss the important events in her life.

You'll put the blame on me for moving our daughter thousands of miles away to an island you never liked. However, you'll move on to save little girls with hazel eyes. Too goddamn young for a man like you. It's insulting, it's cruel but most of all...it's fucking disgusting. You'll know this deep down but your dick and your ego are too proud for common sense to manifest.

I'll have to explain to our daughter why you didn't come after us. Why you never will. I'll have to keep it together as she falls apart over a man not worthy of the title, "father". In secret, in my room (hoping our daughter doesn't notice), I'll think about killing myself. Every day for years, I'm fixated on the idea of dying but the thought of our daughter being raised by you—I'll never go through with it. It's bitterness that keeps me alive.

It'll be me and our daughter for the rest of my life, while you continue to create a new family every five years because you'll need new eyes to be enchanted with. New poetry to write. New pieces to tape together and hope they hold.

Eventually, you'll tell our daughter that you're different now. You've changed. You stopped drinking, you stopped cheating. The only thing that hasn't changed is your smoking, you needed one vice to follow you to your grave. Here's the problem, you've taken too long to realize this. She won't believe you, she won't want a goddamn thing to do with you. Instead, she'll ask how many siblings she has now, she'll ask for the roster.

You'll wonder why she does it but she won't tell you. She'll just look at you like you're worthless, that you're the reason why her mother could never trust men. Why she can't seem to find a decent man to love and love her. Why she doesn't know what the fuck love is thanks to you and me. Our daughter is going to blame us because we showed her what it means to "love". We showed her what love isn't.

We're the reason why she tries so hard to escape the cell we put her in, we're the reason why she married the wrong man. She married someone she thought would save her. She married a man just like her father. Our daughter will convince herself that she must stay in an abusive relationship because this is what soulmates look like. This is love.

I'll be just as bad, don't you worry. The first time her monster chooses alcohol over her, when he becomes irate in darkness and throws a side table at the wall, bouncing off and hitting her to the ground. I'll watch from the doorway and not make a sound. She'll look up at me with tears and fear in her eyes, and I'll do nothing except for the next morning when I tell her, "you will give him a pass to act like this once a year."

She will. Except it's not just once a year. But still, I'll do nothing but watch and fall in love with a man who's just like her father. She chooses to stay with him because I didn't teach her any better. It's because every day and every night when I locked myself in my room for all those years, I taught her what it means to be lonely. In fact, I like to keep her that way so she stays with me. I keep her lonely, even with her beside me. This way she chooses a monster out of patterned behavior, not love. This way, I become the savior she wants.

As I lock myself in my room, as I distract myself until I can fall asleep, I'll have dreams that you come for us. That you save me from the depression that clouds my vision. I'll always hope you'll save me. You don't. It's always just red wine and wishful thinking.

You'll feel our daughter's hatred for you after she calls you out of the blue to tell you she did it, she finally left the monster. Instead of helping her, you abandon her like everyone else. Like me. You disappear because of the guilt eating you away because you know if you had been a better man, a

better father, she wouldn't have fallen for the abusive monster to begin with. I don't disappear necessarily, I make everything worse. I make jokes about how he raped her, I tell her I won't help her with the divorce papers. I'll even let her rapist use our Netflix account for months until she snaps at me.

We are the ones who taught her that loneliness is better than love. We taught her that abandonment is love. That she won't ever be hurt by anyone if she remains lonely. If she separates herself from us completely. We taught her that if she drinks herself into a stupper, if she locks herself away to fight her demons and pain, she won't win.

But I have good news, despite us, our daughter wins. She does what we couldn't. She lives despite what happens to her. She thrives with every path she takes. She learns what love truly is by loving herself and having to reprogram all the years of abuse we subjected her to. She actually goes to therapy unlike us. She takes back her life, the life we tried to stomp out with our addictions.

I do more than just survive my past, I live in the present
and I look forward to the future I know I'll have.

I rise then conquer.

What about you?

you felt it, didn't you?

finally,
a queen
in your presence.

darling, you forget
that you woke me
from my slumber,
and queens always remember
how you made them feel.

now,
watch me conquer
without
a prince of poetry.
without

you.

do you really think you're
Irreplaceable?

a king is rarely remembered,
a Queen always is.

Dear Soulmate,

I have a confession to make. I've been writing
you these letters, assuming I already know who
you are. That we had already met and that soon
we would have our time again.

But I'm afraid I was wrong. I'm afraid that we
probably haven't met yet and I've spent so much
time caring for someone who isn't you.

I should feel relieved but instead all I feel is
heartbroken. Holding onto someone who isn't you—
I've never felt like such a fool. Not like this.

You would think my past relationships were pain-
ful, and they were. But then this man came along
and he changed everything. My entire world, even
though it was for the better. That's why I feel
like a fool.

I thought he saved me, I thought he was more
than my awakening. I thought Ares was the worst

heartbreak I had endured, but Eros...he was the lightening in my sky. The disruption of time and space. Of my dreams. I made the mistake of caring for someone who couldn't even stand to be seen outside of his darkness.

One day, when we do meet, I hope that we're given the time to grow together. To face the sun and nurture our relationship in love, in laughter and hope and dreams.

Forgive me for thinking someone else was you. For hoping he was you too.

Now I know.

Your Equal,
LJ

Dear Soulmate,

I didn't mention this in the last letter but one of the reasons I wasn't writing for a while was because I had lost my mind.

I was moving on from the idea, the infatuation, of Eros when I found Hermes.

I fell in "love" with a one-night stand—terrible idea by the way. Not one-night stands but falling for men who are incapable of loving me. Men who really should only be an indulgence for a night and nothing more.

He wasn't the only reason though. My health. My house. My job. Everything just fell apart after working so hard this year to rebuild. I have terrible coping mechanisms, I realized though. One is to run away. Another is to drink it away. To eat it away, starve it away, and lastly, to fuck it away. Pain, that is. One day, I'll tell you where I learned such things, but not yet. Not now. I'm working on it though. Trying my hardest to heal before we have our time.

Lately, I've been thinking a lot about soulmates though. Sometimes I wonder, what if we've already met them but the timing was off? We're either acquaintances, friends or brief lovers. But we just don't know it because again, timing. No, that's not it. It can't be. Can it? I hope not. I hope you're a complete and utterly wonderful surprise.

I've also been contemplating about souls—if we're all broken and that's why we're born. We're born in this body to heal our souls and once healed; we die to go home. Or maybe, the body is a cocoon to keep us safe as we grow until our hearts are too large for the body because we're no longer in pieces. Or...

Or maybe none of this fucking exists. Timing. Soulmates. Nothing. We feel this love, these chemicals going off and believe it's magic. What if it isn't real and I've been writing you these letters—for nothing. Because what if you're not real? Maybe it's this recent heartache that has me falling further away. If we have met, if we were just strangers in a book shop or crossing the street in Edinburgh or reading in a café in Belgrade. Or even if you're just an ocean away...I hope one day we get a real chance at this. I hope I'm proven wrong.

Holy granola, I hope I'm proven wrong.

Your Equal,
LJ

Dear Soulmate,

Slowly, I'm piecing myself back together again. I once told someone—Hermes—that I was made up of the pieces of everyone I've ever known—a collector. I didn't realize how wrong I was until he collected me. It's only now that I've awakened that I was never comfortable enough to be myself with him, not really. I didn't necessarily change for him, but I did change because of him. Karmic relationships, I've been told.

Losing him made me realize how much I did need to wake up to my own behavior, along with spotting shitty behavior in others. I've never cried this much over someone before—not in this way and for this reason. As a girl, I cried because someone wasn't "mine". As a woman, I'm crying because I gave him so much of myself and received nothing in return. I let myself down by begging for him to want me as I wanted him.

The original letter of this date is somehow more pathetic than this one because at the time I hadn't known all about him yet. In the letter, I'm speaking of regrets and bad timing. In the letter, I'm literally losing pieces of me for his precious collection...again.

"What I would give, what I would do, to rebuild with him."

Fucking pathetic. I'm sure you've felt this way about someone before though. Where you fucked up and then realized you're not the only one who is fucked up too. They just make it seem like it's all you.

I've learned my lesson though, as I've said. By losing him, I learned that I deserve more, that I deserve Love. Many men have come into my life and have showed me that I can be head over heels with infatuation, but no one compared to him and how my heart twisted from my actions and his. It wasn't Love, clearly. However, it seemed like the closest I had ever experienced.

With every heartbreak, despite new lines for poetry, I know my heart only grows larger. Increases in my ability to love. One day, I will fall in love, then I'll rise with you.

However, in my downward spiral, my summer madness, I showed my unhealed trauma. I never meant to cause pain to others. But the thing about life is, it keeps moving whether you want it to or not.

Hermes wasn't the first man to hurt my heart. But I do hope he's the last, for this year at least. There was one man before him who showed me these same lessons, but I hadn't listened. His name is Eros (unofficially, of course).

I had written a poem to Eros, another man who was once in my life and held such weight. It's somehow more heartbreaking reading this months later. Add this into the "lessons learned" jar, if there is such a thing.

Dear Eros,

You're in love with love.
You're in love with infatuation.
You're in love with every woman that crosses your path.
And I'm the fool, the poet, who felt
too much—too soon.

You're my Eros, I'm your Psyche.
I'm the beautiful woman that men would admire then leave.
How could I have forgotten; men are made in the gods' reflections.

You're in love with love.
You're in love with infatuation.
You're in love with every strong woman that crosses your path.
And I'm the fool, the poet, who felt
too much—too soon.

Psyche was a mortal girl
Who spent her entire life caged in abuse
And left for dead on the cliff's edge.
I wish I could have told her my newfound truth.

Eros never looks for her,
never finds her, never bothers.
He stays hidden beneath his costume, in the darkness,
even when they have a moment together.
But Eros is the god of love.
How could she not fall for him?
How could I not fall for you?

How poetic, the abused girl falling for the god of love.
Eros, the one who knows nothing of love.
Who prefers temporary forevers and muses for his pleasure.
You're in love with love.
You're in love with infatuation.
You're in love with every brave woman who crosses your path.
And I'm the fool, the poet, who felt
too much—too soon.

My dear Eros,
I am more than a mortal.
I am more than a muse.
I am the goddess of
the soul.

I wrote this to and for him, yet all I see is myself. I'm in love with love because I've lacked love my entire life. This recent heartbreak showed me that I have more love to give than I've ever received and it's the saddest thing to me.

But maybe it's this love that will heal me, finally. Instead of giving others this newly discovered untapped well of love within me, I'll keep it for myself for awhile.

I learned from my dear friend Alex Van Frank that attachment happens when there is the lack of authenticity, and the lack of authenticity is usually the lack of self-love and self-worth. It's what happens when you wear a mask and eventually that is who you become.

Soulmate, whoever you are, I'm going to heal from my trauma further and to love myself softer. I'll especially learn the difference between authenticity and attachment before meeting you.

I hope you do too.

Your Equal,
LJ

Love Lesson #3:

I wanted to discuss heartbreak. How the hope for love can be misguiding you into believing a fantasy that you've constructed in your head. You're not alone, I just experienced this myself.

You're so hopeful for a relationship, for true love, because you have so much to give. That's amazing and I'm so proud of you for that. We all experience this at least once, especially those who have been abused. Experiencing a connection with someone who is also benevolent—of course, you wanted things to work. No one has treated you that way in the past, this was somehow going to be different. I get it. I do.

Most of my previous relationships ended because I was cheated on. One epic breakup included me in a room with his new girlfriend, her friends and her family as my ex dumped me in front of all them. I was supposed to be the entertainment for the evening. To make them laugh as they watched me beg. I didn't. I think they might have been disappointed. I was not.

Now for the heavier portion—I have been raped, hit with furniture and degraded in every possible way a human can be. I've dated a plethora of callous men and this is what I can tell you about my experiences...

I didn't know that I deserved so much more than what I kept settling for. I never had a loving and healthy relationship to look up to. I never knew that love and war should not coincide. I never knew what love was but always dreamt of something so special and beautiful. I thought suffering in love was normal.

Always trapped in a dream rather than facing the reality of it all. That abuse in love is not okay. That shitty behavior is not okay. Again, I was confined in my dreams of what love with that specific person could be. I was hopeful for a *Happily Ever After* kind of ending.

If you couldn't tell by my poetry and letters, I'm always very hopeful for love. I believe in benevolence and seeing the good in everyone. It's one of my greatest strengths and one of my greatest weaknesses besides transparency. However, through every heart-break I learn something new about myself (and I'm sure you will too). I hope what I've learned recently helps you in some way or another, even if it's just to reaffirm what you already know.

I believe in leaving a relationship with grace, no matter how much they want to hurt you or how much they have or do—you don't need to be unkind too.

I believe in being the best possible ex you can be. No mix signals, no drunken phone calls, no begging—nothing. I turn into a ghost of your past and I stay there, happily.

I believe that we deserve every star in the sky and people willing to defy gravity to reach them. Again I have been reminded of what I deserve. Heartbreak is a lesson, not a failure. And despite feeling absolutely ridiculous right now, I at least know who I am.

I know that despite everything I've been through, there's someone out there for me. Someone who will see my scars and not runaway. I know that I'm a hopeful romantic because the idea of being hopeless again frightens me. That I refuse to change for the worst when my heart hurts and with every painful punch life throws at me, I hit back harder. I know who I am—most people can't say that.

I believe in not creating a fantasy in my head anymore. If someone wants you, they'll do anything to make it happen but if not, they won't. I'm so happy that's been made clear to me. I believe in not sitting at home and crying with a pint of ice cream while stalking ex-lovers on social media. Fuck that. This also isn't the time to wear a revenge outfit or lose weight just to "show them". Fuck that x2. I believe in doing what we do every day, being Queens.

When your heart breaks, release the emotions but don't let it stop you from being who you are. You're a Queen, not a princess or a damsel or a slave to your emotions. You are not to venture to Neverland, to follow the one who doesn't want you. To where boys will be boys and men will be boys too. Where there's jealous pixie's pulling your hair and love becoming only smoke and mirrors.

But Wonderland—yes, Wonderland. That's where there's fierce queens, some mad with dreams, a fuck ton of tea, consistently fashionably late is okay and tables covered with delicious pastries. Falling down the rabbit hole, I find myself somewhere new. Wonderland is where I choose to be. I hope you choose it too.

There's too many adventures and dreams and people to be sad over one person who doesn't want you. Dress, eat, drink, make-love, love—in the way you deserve. Chin up and be grateful for what you've learned. Hearts heal with adventure, with self-love and self-care.

Hearts always heal.

With that being said...I'm going to explore Wonderland.

I'll see you there.

YOU'RE NOT RECKLESS WITH OTHER'S HEARTS.

YOU'RE RECKLESS WITH YOURS.

Dear Soulmate,

I'm not too sure what I believe in. I feel like my views are always changing. Perse-phone has been taking care of my heart lately as it's too heavy for me to hold alone. After work, we walked to her car and watched the stars rise as we discussed my love life. Or the failing of it. However, you want to dissect that.

Cautiously, her eyes flickered towards the car window and back. The streetlights casting a warm glow across the dashboard and painting our skin in fragments of orange and gold. She released her held breath and said, "I don't want you to take this the wrong way. I don't want to dim your light…"

"But…?" I asked quietly, reluctantly.

"You are filled with love and so much light. You're able to love easily, boldly—it's intense and I love it. But not everyone can love the way you love, LJ. Sometimes it takes people a long time to be able to love as you do. So, if he doesn't write back or if he doesn't call—if he doesn't say anything and that's his answer, I don't want your heart to be crushed." She licked her lips and bit down before speaking again, "you're rare, you know? You love differently than most. You love freely, without asking for anything in return. I think that's beautiful."

Tears swelled in my eyes, but I had cried for a week straight and I was tired of doing such an exhausting activity. I cried outside as I laid topless in the sun; my back shak-ing as I hugged the ground for support. I cried on a park bench into my friend's chest as he held me, as he reassured me that it will all workout in time. I cried in the break room when someone asked me a simple question, "are you alright?"

I didn't want to cry anymore, no.

I wanted to show her that despite feeling my heart barely beating—my heart break-ing—I can still love, unconditionally. "I understand," I whispered, "I do. Thank you."

Persephone gave me another smile, this time brighter than before. I knew what she was saying, I knew it was time to let him go. He didn't care about me as I cared about him. I was just another one to add to his collection.

I never told her how much that night meant to me. That despite being surrounded by darkness, she pulled me out of it (she also understands darkness all too well). Persephone reminded me of who I am. She reminded me that I deserved someone who would write back to my letters, who wouldn't tear apart the dried lavender I sent to him for his bath, who would understand that despite my trauma, I'm trying my hardest to heal myself whole.

She understands that I can love unconditionally, quickly and easily, because I know what it's like to not be loved at all. But she also wants more than anything to protect me and my heart of gold.

"Please guard your heart, LJ. Not everyone deserves to hold such beauty."

I'm taking her advice, finally.

Your Equal,
LJ

Update:

It's true; she was right. Which got me thinking, why have I denied myself of this serenity? Why haven't I protected myself, my heart?

It's because men kept telling me, "I'll keep you safe," and foolishly, I believed them. They take the last of all the words that mean anything to me—they steal them, reminding me how worthless words can be. A man once told me, "I hope we cross paths again," and I believed him. He messed with my head, posting cryptic messages and pointed poems. I wonder how many women he does this to? Feeding fantasies, craving muses because he lacks the ability to ignite from his own creativity.

I told myself, "plenty of women. you're no different from the last nor the next. Just another muse, another one for him to imprison in black ink and whiskey stains."

My poor heart made of glass and gold. Cracked and dented, too young to look this old. None of these men gave a damn about me, not the ones standing in the light, swimming in the ocean, or hiding in the fucking shadows.

I did the unthinkable then. I took my heart and placed it on an alter of flames to keep it warm. I vowed to wait for my Equal before letting another enter my temple. I began building my throne. I learned that no one, and I mean no one, will protect you. No one will take care of you or love you like you will for yourself. I learned to do just that. To love myself completely. To keep myself safe.

She told me, "please guard your heart, LJ." A single tear slid down my cheek, falling helplessly onto my hand, "not everyone deserves to hold such beauty."

IT'S HARD TO BE A KIND WOMAN

TO UNKIND MEN

BUT I APPLAUD THE WOMAN WHO DO

AND I GIVE A STANDING OVATION TO THOSE WHO

LEAVE THEM

Dear Soulmate,

I've been reverting to old patterns again. I've been distracting myself from my dreams... again. My body is thoroughly over it.

I'm not sick. That's what I say, that's what I believe. But sometimes, my body feels different- ly. The thing is, she knows what's best for me.

I kept giving in to these men who treated me less than garbage. At least garbage will be collected at some point or another. One man's trash is another's treasure, isn't that the horrendous saying?

Well, they treated me less than I deserved. It's taken me awhile to realize, I can do better. My body is tired of my painful decisions to love those who can't reciprocate such feelings. My body is tired that I keep confusing infatuation for love.

She reminds me by flaring up and yelling. My joints, my muscles—everything aches incredibly. I've never known a pain like this. Where the aches scream louder than my own voice.

At five in the morning, I was laying on the bathroom floor, screaming so loud I didn't know I was screaming. I wasn't outside of my body; I was trapped within it. The pain was un- bearable, my stomach felt twisted and the nausea was something otherworldly. I clenched my phone, pressing my sweaty face into the cold tile and begged for my friend to come get me though she lived across town.

"Go to the ER. Now." She urged several times.

I made it the door. My mother slowly walked behind me. We piled in the car and she paused for a moment, to clean the dog hair off her shirt as I was crying. I snapped at her, not feeling any regret as the pain crashed through me.

I'm not sick. That's what I told myself, what I tell myself every day. At the ER, they gave me medication after medication—I nearly forgot to tell them about my infections I had been trying to fight. They gave me more medication for that too.

The worst part was realizing that despite being surrounded by people, I was still alone. I've always been alone. Loneliness is as much a part of me as my own limbs, my own heart.

I was told surgery is a possibility. I was told that my infections could be spreading. More drugs, more tests. Why is my body failing me?

She's tired. She's exhausted of being ignored, of being treated less than her worth. This is her screaming at me to pay attention to her.

Loneliness drove me into the arms of men who didn't deserve my heart. Loneliness drove me into friendships that should have ended before they could start. Loneliness. It's the deadliest disease out of all them, even the infection that was killing me.

I'm still learning how to navigate through mine. I can handle being alone for a while and then...I can't anymore. I turn into a mess, I fall apart.

I give in. I fall in love, in infatuation, with those who are experts at ghosting. I fall for those unable to be there for me. To love me, properly. I choose the men who I shouldn't fuck with and I always give in. Always.

Then there's you. You will not be picked out of loneliness. You will be chosen by the heavens, by the stars above. How they dream of only Us.

I will not be chosen because of your own loneliness either. I will not be the woman who you cling to until you find another muse. I've already been that type of woman for many others and I'm tired.

I'm so goddamn tired. My body aches, my body screams, "ENOUGH!" She refuses to be my vessel any longer if I treat her less than she deserves. If I choose another man less than my worth. If I settle.

My body would rather rot away than be admired by another pair of cerulean eyes. She is done. Done with my poor choices and not being heard. Of not listening to her.

She chooses loneliness and I do too.

Because nothing is as hurtful, as terrible and cruel, as choosing a man who doesn't want you. As choosing a partner over yourself. As giving your love away to someone who doesn't know how to hold such a precious heart.

I will not choose you out of Loneliness, I will choose you out of Love.

Your Equal,
LJ

I'M SCARED TO GIVE

MY HEART, MY SOUL, MY STORIES

OF ADVENTURES, THE ONES OF

DIFFICULTIES AND GOLD.

I'M SCARED TO GIVE

TO SOMEONE LESS,

LESS THAN WHOLE.

BECAUSE I REFUSE TO

REPEAT THE PAST

OF GIVING SOMEONE MY PIECES

TO MAKE THEM FULL.

Dear Soulmate,

I figured out why it had hurt so much, with Hermes. With Eros. Even with Ares.

It wasn't my heart that they had broken, it was my hope. Hope is what has given me strength to survive. I could work through my past by having hope for the future, especially a future with someone else. Not only would I be relying on myself then, they'd be relying on me. I'd be relying on them too. Equals, is what I mean.

Ares. I had hoped that he would save me. I had hoped that he would keep me safe since my parents couldn't. Since no one ever did before. He turned out to be just like them, but worse. He had siphoned my hope; he had taken it to keep only for himself. When we had broken up, I felt nothing but relief. I've always questioned how much I loved him, I always questioned how much I loved me. It's been nearly a year and he's still haunting my dreams.

Eros. He enlightened me, he opened me up to vulnerability. He gave me hope when mine was stolen. But he wasn't meant to stay, he wasn't meant for anything more than a wake-up call. The catalyst of it all. The problem was that I wanted more, he wanted someone younger. I wanted love; he wanted a muse. I was a fool. I created a fantasy in my head, in my heart. I had hoped that one day we would be something more. I held onto him, I held onto the hope of him because I couldn't believe in myself. I didn't know how to. I wanted love; he wanted a muse. I wanted him; he wanted a nineteen-year-old.

Hermes. It was supposed to be nothing more than one night. It then escalated and elevated until we were too high and lacked the oxygen needed to survive. I had hoped he was the one. I had told myself earlier this year, summer—that's when you're going to meet the love of your life. Your soulmate. I had never been more wrong; I had never felt more hopeless before. On edge, falling apart, I still held on in hopes of healing my heart.

Hope. That was the key with all of them. Or at least the similarity. I had relied, I had given, I had begged—for love, for hope, for a future with them. In one way or another, I received my wish. I had a future with them, just not the one I wanted. Thankfully.

It's silly, isn't it? To want someone so badly that you lose yourself. This year of men made me realize just how much I wanted to heal. How much I wanted to attract better by being better.

I wish I could say that I healed within less than a year, that I've fully recovered from the abuse of twenty-seven years. I wish I could say I was ready to meet someone worth falling in love with. To meet someone worthy of me.

I wish I could say I know exactly what a healthy relationship should be. I wish I could say I'm ready for one right now.

But I'm not. This summer (this entire year, really) showed me exactly where I stand. Where I need to be. Alone.

I grew up alone. I've always been alone even with a man beside me, even with friends beside me. I was so tired of feeling that way, so I tried and tried until I still ended up lonely.

I figured out why it had hurt so much with Hermes. With Eros. Even with Ares.

I stole my own love, my own heart, to give it to men who couldn't hold such a thing. They didn't ask for it, not really. When looking back at these men, I should have run.

I gave them all my hope, because I was desperate not to be alone anymore. So, they collected me. In their poems, paintings and their memories. Whether I was the goddess, the villain or the damaged goods—I was there in their pages.

"Don't forget me," I always whispered. That was my hope, to not be forgotten like when I was a child. "Don't forget me."

I forgot about myself. Believe me, that's much worse than being alone. I forgot about my own hopes and dreams, I forgot about me because I wanted to be loved and love.

Hope. This is where love is birthed, this is where hearts flutter when they first meet, this is where dreams learn how to transform into reality.

I may lose hope in you, but I'm not going to lose hope in me.

I'm going to be alone this time, for a while, maybe longer I think. At least until the day I realize that loneliness and hope can coincide equally.

Your Equal,
LJ

Love Lesson #4:

You lose focus on yourself every time someone pays you any attention. You lose focus on your dreams and ambitions because you're so desperate for love. It's not that you need to be loved, that was never it. You were never given love to begin with, never in your childhood and adolescence. It's the love that you carry within you. It's that you have so much love to give and you don't know what to do with all of it.

Instead of giving it to yourself, you search for someone else. You search for your soulmate in every face that passes by. You search for connection, for any signs of life. Then you give—you pour yourself into someone unworthy of your love and affection. Completely and utterly unworthy of you.

You give it all until they have drained you dry and left you behind. Then as you swear off your terrible habit of loving so fiercely, you begin to create more love within yourself. You fill yourself up, you make yourself whole with the kind of love only you can create.

And again, you drain yourself dry.

I hope instead of giving your love away, you keep it for yourself this time. Learn that love is more than giving, love is being selfish from time to time. Love is taking care of yourself, putting the mask on before helping another with theirs.

I hope instead of giving your love away to those unworthy of you, you find someone who is kind. You find someone who understands exactly what it's like to Love the way you Love. You find someone who can and will love you for exactly who you are.

Dear Soulmate,

I've learned that I'm "damaged goods" from the men I've dated. I've always been too hard to love because I've been through too much. A past that I had no control over, events that tore me apart and left me in pieces at my monsters' feet.

I could see it in their eyes, hear it in their voices—I was too damaged for love, especially theirs. I was not a whole woman; I was a broken one.

I thought I found love and at the time I genuinely thought I did; it just wasn't felt to the same depth. It wasn't felt at all it seems. I cursed the world, I cursed it all. I thought I had found the One—you—but really, he was only a person bundled with lessons to give and for me to receive.

Looking over my shoulder, I paused in the doorway and felt teardrops breaking free, "I thought he was the One." My whisper barely found her, but she heard me still.

"I know..." she replied softly before I closed the door. Descending the steps, I opened the last door but even the sunlight felt cold. Everything feels a bit colder now that he's gone.

I think he stole my light to feed his own.

I'm damaged goods though, it's what I've been told and what I've been shown. It's what he said. After this lesson in love, I felt myself unravel. Is this how it will always be? Believing in something that isn't true?

Do you want to know what my dear friend told me? I'm sure you do, as reading this is probably going to frighten you. That someone who gives so much, who cares so much for love, has lost hope in you?

She asked, "do you believe in gravity?"

"Yes," I replied.

"And if you do or do not, gravity is still there isn't it?"

"Yes. Yes, it is."

"Then so are soulmates, so is love. Whether you continue to believe in it or choose not to—it doesn't matter, it's there. Your soulmate is out there and one day you two will find one another and you'll forget the men who could not love a wild heart, a gentle soul and a light like yours."

Biting my lip, I felt the tears build then race down my lashes. Unable to say anything more, I nodded. I believed her—I always have and always will.

So, like gravity, we'll fall into one another soon enough. Whether we choose to believe or not, the Universe has other plans for us.

I'm not damaged goods, I never have been, and I never will be. Their words may have stained my skin but nothing is permanent.

I'm healing as much as I can before finding you. I may be speculative of you now, but it doesn't mean anything when gravity is real. You're real, somewhere, someday and some-how.

Your Equal,
LJ

Love Lesson #5:

If you haven't met your Equal yet, perhaps it's be-
cause you both need time to grow a bit more. Wheth-
er it be lessons in self-love/worth or not being so
focused on bodies but the souls within them, or you
have a crippling fear of sharks and they just so hap-
pen to be a shark doctor (is that a profession??).

Can you imagine it though? Waking up in the arms of
someone who doesn't complete you, but mirrors you?
They're benevolent, humble, intelligent, ambitious,
tender, brave, loyal—that sounds beautiful to me.

I believe in soulmates, in love. When I saw every-
thing fall apart around me, I realized there's some-
one out there who would search the universe for me
even if it meant just a moment to hold my hand, kiss
me goodbye and say, "I'll find you in the next life."

So, keep moving forward with the same relentless hope
that I have.

Be cool, focus on you.

Love is coming...

Dear Soulmate,

I've nearly given up on you, but my friends told me not to. It seems my hope for you rubbed off on them, so much so that even they're waiting on your arrival.

I must tell you though, you are not going to have an easy time getting to know me and this glass heart of mine (I thought it was solid gold, turns out it's definitely glass). So many walls have been built around my heart. Walls, thorns, salt, sand, moats—anything and everything to keep myself safe again. You are not going to have it easy and it might be a very long time till I trust you and open up to you, but I've been told that anything worth having takes time.

A dear friend of mine told me that I would be on my guard and have trust issues thanks to my past—that the next man will have the most difficult time thanks to the men before. I didn't want to believe him, but now I do.

I gave my heart away to someone who didn't know how to cradle such a thing, someone who wasn't worthy. I've done this with many men. I have this uncanny ability to love unconditionally—to love anyone and everyone. However, with time and space, I've realized that I've never been in love, not really. How could you possibly love another if you can't love yourself?

That's what I've been working on. Me.

I will not tell you I love you right away, but it doesn't mean I won't feel it—it doesn't mean I won't show it. I will not speak of my past, but it doesn't mean you won't see it—it doesn't mean I'll hide it. If anything, you will get to the point of wanting to give up and instead, if you hold my hand and take me to the sea, beneath the stars and ask me for the truth—maybe by then you'll have earned my trust and my stories.

As you slowly put together the pieces of my history, you'll understand why I am the way I am. But I want to give you some advice, maybe this will soothe your worrying.

First, you'll need to make it through a sandy desert, watch out for quicksand and snakes. Wear a mask and goggles, it might help you brave the sandstorms coming your way. Next, you'll need to face the rose bushes as tall as castle walls. With spikes instead of thorns, move forward slowly and softly. From there, you'll encounter two lines of salt— this is to make sure you're not a demon after all. If you manage to get past those defenses, I promise you, there's more.

A moat of monsters (I don't suggest swimming—you'll need to use your wings to get across). Within this lovely moat, there's salt-water crocodiles—I brought them back for this occasion. I think they might be able to jump out of water too—fly high—that's my advice for you. And though you'll be out of breath and exhausted, there's a giant wall of beautiful gemstones that tower towards the clouds. Every day, you'll calculate how in

the heavens you'll be able to get past this defense. Your wings can barely carry you now as exhaustion sets into your bones.

You'll see a chair with a blue velvet cushion and flowers carved out of wood. Take a seat and stone by stone, you'll make your way through. I'll leave you food and water, blankets and some kind of shelter. Books too. I'm not cruel, I'm merely seeing if you're worthy.

But just when you think it's over, the last defense is fire. My own flame keeping my heart from turning cold from all the experiences before. You will burn if your intentions are not clear, if you have no intentions at all but was curious to know who I am. You will not burn, if your hands are made of love and benevolence. You will not burn, if you treat me as I deserve.

I will never apologize for the work you will endure...I know my worth.

Wherever you are, whoever you are...I believe in you, I know your worth too. Take your time in getting to know me, that's my advice for you.

Your Equal,
LJ

he will be better.

in love,
in bed,
in heart,
in soul.

to the heart

i hope to find

one day,

my love poems

are for

you.

Part five

all my life,

i've been waiting for you.

praying on the stars,

begging to the moon.

i hadn't realized,

how silly it was,

to want someone so much.

but i guess that's what happens,

when i have no self-love.

Have I tethered all my hope to you?
Have you become my safety net since I've only ever felt that with you?
Have I crippled myself yet again by relying on someone else?
Please, tell me,
It isn't so.
Please, tell me,
I don't have to let you go.

Let him go.

Could you ever not rely on someone else?

Could you just get through one day without wanting to sink into another relationship you're not ready for?

Could you stop settling for those unworthy of you because you're lonely?

Could you just work on yourself, focus on yourself?

Could you just find the love within yourself and not someone's sheets?

Could you?

I hope you answered yes.

Dear Soulmate,

I've become hopeless in romance. Waiting on you, writing to you. It's insane. Loneliness has corroded my senses.

If you are out there, if you are real...I won't believe it. I don't believe it. I am writing to some fictional person because you're not real. This is not real. It's all in my head. It is.

I believed in you. I believed that I would be proven right. That soulmates exist, still in this time. In this society of swiping left and swiping right, true love could still be found and thrive.

It is not Love. These letters, these poems are just infatuations for a soul who doesn't exist.

I am here. Alone. I was made whole. I was made with every bit of courage and hope to survive. I am here to live, not find another to live with. I am not here to be a counterpart to someone else's existence. If you even fucking exist. I am here. A witness to darkness, to hopelessness. I am here, still living in the abyss.

And where are you? Huh? I gave in to fantasy after fantasy. I gave in to false reality, assuming love was waiting in this elusive dream world. You are a soul, another lonely soul. Not split from mine, not made from me or for me. You are just another soul given a body to call home.

I believed in you. I believed in a fantasy. I believed it so much so that I wanted

it to be true. But even if you are real, I don't believe you. In you. Not anymore.

You know, my favorite holiday is Valentine's day. Isn't that typical? The girl obsessed with finding love, loves a holiday for Love. Pathetic, isn't it? Don't worry, I'll answer that for you. Why yes, yes, it is. It's just as bad as writing letters to someone who isn't reading them.

Men want these women who are so fucking hopeful and happy and brilliant and beautiful. Society puts this insane amount of pressure on women to find love, to not be lonely for too long. Let me tell you what I've learned recently.

With each sword stabbed into my back, I pushed them in further, with little to no help from the culprit. They see how easy it is for me to love and they prey on someone with a heart like mine because I give and give and give until there is nothing left of me.

My body. My heart. My soul. There is nothing left of me. Until...

Until I swear them all off and beg to be left in peace. One by one, the swords begin to fall from my back as my wings push them out of my flesh. I believed in soulmates, in a fantasy.

I believed in you.

But where were you when I needed you? Where were you? Where are you? Do you think my life has been fucking easy? I needed you, I needed to be saved so many times from my monsters. Where were you? Where are you?

Exactly. Nowhere. Because you're not real. These letters are to merely help me navigate through my loneliness. My hopelessness. My own lack of self-worth. My insanity of being left to my own devices and addictions because I haven't a clue on how to cope after being raped. To cope with having a narcisstic, alcoholic, womanizing father who I barely remember his face because it's been so long since I last spoke to him. To cope with a controlling, manipulitve and depressed mother who to this day wants *me* to save *her*. Me to raise her.

I needed you. Or so I thought. What happens when you realize, it's only you? That love only exists in you and that you give it to the world so quickly? Too quickly? That's why you feel depleted of energy, of love.

Do I leave the reader with hope? Or the truth? Can there be hope in truth?

Where were you, my soulmate, when I fucking needed you? I believed in you. I believed in someone who isn't real. That's my truth. These were for you, every word, every sentence, every goddamn letter was for you. But I'm taking them back.

They're mine now.

I deserve love letters. I deserve hope in myself. I deserve more than hoping some man will be my soulmate, I deserve more than waiting for him to show. This was a fantasy. This was a lesson. That is all. Nothing less and nothing more. I have nothing to show...except more hope in truth.

Soulmates are within us. Already bound, woven together. Two eyes, two lungs, two arms and two legs. We are already whole in our own hearts, in our

own way, why do you think we were only given one?

We have always been told we needed more; we needed another soul to survive this life. To be loved and love and loved and love again. This is a book for the hopeful who turned hopeless just like me.

You are your own soulmate.

Whoever you are searching for, is within you. These bodies, these souls that we find and love, they are not ours. They are not home. They are not a soulmate or a twin flame or whatever you want to label them as.

They're not you.

I believed in soulmates. I believed that you would find me. How wrong of me to presume such magic existed still.

So, I'm taking these letters back. These poems. Everything I've written for you.

I'll heal with therapy, self-love, self-care and reflection. I'll heal with my friends and airline tickets—traveling. Fucking traveling! I'll heal myself whole instead of waiting for a soulmate to find me eventually. I'll heal so no one has to save me.

I believe in me.

Your Equal,
LJ

stop teaching girls that bad men
are redeemable.

stop teaching girls that their
feelings are invalid.

stop teaching girls that its safer to
lie than to speak their minds.

Teach girls that they don't need a significant other to survive, to thrive. Queens do not need a counterpart to rule.

Teach girls that it's not because they're hungry or tired or pms-ing that they feel the way they feel.

Teach them that they don't need an excuse to feel.

Teach girls that their voices are a superpower and need/want to be heard.

Teach girls that their bodies will always change. We were not born to stay the same, we were born to evolve.

Teach girls that true love resides within themselves, not in the fairytales.

Teach them.

So we don't continue a pattern of broken hearts, sad eyes, bright smiles and inherited insecurities. Imagine how different the world would be, if we all grew up being taught such things.

I don't need you to rescue my
heart.

I have a blade (books),
and my wits.

```
               I have my Own
                  Money
                 Shelter
                  Water
                   Food
                   Love

        Now, please tell me, why you?
```

Don't worry. I'll wait. Keep thinking on this one.

MAYBE

I JUST WANT

MONEY AND

SEX AND

SUCCESS.

M A Y B E

I want equal rights, equal pay and my own goddamn freedom with my body.

I want to listen to voices from women of color take over the world. I want to listen to them fucking roar after being chained in silence.

I want to walk home safely, I want to feel safe.

I want to watch patriarchy crumble while I eat an entire cake that says, "work through your goddamn fragile masculinity issues." I want men to be held accountable.

I want to fix the enviornment. Heal the Earth. Save the goddamn oceans.

I want to unlearn white feminism because that's crushing our society just as badly as the patriarchy.

I want to fix the healthcare system that's been built for profit rather than saving lives.

I want the younger generations to not feel like they are the only ones who give a shit about this world, that it's somehow up to them to fix it if they want to live.

I want influencers, celebrities and corporations to step the fuck up and be aware of what they're promoting because eating disorders are not sexy.

I want to eat another fucking cake with the words, "No Maybe's. This is exactly what I want."

I want a lot more than what's on this list. Maybe I'll write another book about it.

Part Six

I WILL NOT
TELL YOU MY WORTH.

I WILL NOT FIGHT
FOR YOUR ATTENTION.

I WILL NOT
BEG YOU TO STAY.

YOU'RE LOOKING AT
A WOMAN WITH WINGS,
NOT A GIRL
WITH INSECURITIES.

You are more than the words you write.

You are more than the emotions you feel.

You are more than the thoughts that plague you.

If only you knew, what the future holds for you.

Maybe then you'd see the magic I see in you.

Every woman deserves
pretty armor.

We also deserve some
fucking Respect.

...and flowers...

...and wine...

...and adventure...

"Do you think the next man will be kind?" I asked myself one night.

"I do," my heart sung.

"No, bitch. They all lie," said my mind.

"Lets not worry about the next man. Just focus on you," replied my soul.

A

LIONESS

DOESN'T

PLAY

WITH

SHEEP

encourage
women
to be themselves.

we're
remarkable
when we choose
to love our bodies
and
we're
unstoppable
when we do.

Dear Me,

You fell for the wrong one again. You'd think you'd be tired by now, all this falling. That you'd be done with love, forever. You almost were for a hot minute. Can't say I blame you after the last one.

One of your best friend's said, "you realize he was a monster too, don't you? Just like the rest of them."

I nodded, knowing that there was no use in holding onto my demons. They always break out of their cages, even the ones built within my memories. Isn't it funny? Monsters break out of their cages easily. Yet the rest of us stand here, afraid of love and build up another layer of our own.

We build walls.

We build cages.

We build what we're told.

I don't know about you, but I'm rather tired of building someone else's castles. I want a throne of my own. I'm thinking that as much as I'd love a soulmate who becomes my future husband and then having children together...I want Me more.

I want my freedom to explore my own heart in my own hands. I want to carry myself to the end. I want to love myself for who I was, who I am and who I am becoming.

Maybe I have been burned, maybe I let them burn me. But even my body is rejecting knights and fools. I think my body knows it's time...

One by one, I build my throne. Not of stones or sticks or snakes or swords. No. My throne is made of kindness, stars, obsidian seashells, and mint-chip ice cream cartons. Of cerulean glass and wit and dreams.

My throne is me.

A soulmate and children are a dream of mine but...I'm happy even if that's not in my deck of cards in this life. I'm happy, because I have a goddamn throne of mint-chip ice cream.

Love Lesson #6:

You keep searching for love not realizing there's an abundance of love within you. Be your own soulmate first and foremost. It's not selfish, it's not bizarre—it's beautiful. You have so many dreams to accomplish, so many places to go. My goodness, you have an entire world to see. Sunsets in Dubai and lingerie shopping in Paris and eating all the delicious food across Umbria. You don't have any more time to waste in this life on people who do not truly want you for you.

A little perspective if you're feeling down though (my apologies in advance for the very hetero example), there's at least three billion men out there. Three. Billion. Men. *Clears throat and blushes in the prettiest shade of pink you will ever see*. There's a plethora of men who want you, but you're focused on that one guy—that one fish who doesn't give a damn about you. If that one fish doesn't want you, maybe that's a good thing. Find the dolphins, they give hugs and protect you from sharks. Gotta love em.

But first, I hope you fall in love with yourself. It's a really wonderful experience. Get dolled up, take yourself out. I went to this fancy sushi place last night and sat alone in the middle of the restaurant surrounded by all these happy couples and families and I couldn't help but smile. One day that's going to be me, just like one day that's going to be you too. Adventure—see the world for how magical it is. Go out and live, true love will find you eventually.

Did you know that a handful of dirt has millions of living microorganisms in it? That's magic.

Did you know that grass and palm trees are both monocots? That's magic.

Did you know that you can fall in love with yourself instead of relying on someone else to give you that love? Yeah. That's magic too.

I'M AN ANGEL

WHO NEEDS TO BE

SAVED

BY HER OWN

WINGS

men have fallen in love with me,
only seeing a girl in
pieces
rather than a woman who is
whole.

which one will you see?

you know what?
fuck that.
this is me.

i'm the little girl who faced
demons and dragons and
slayed each one of them.

i'm the woman who married
a beast in hopes there'd be a king hiding beneath.
there wasn't, so, i let his own sword defeat him.

i'm the queen who fell for a prince,
one who didn't give a shit about me,
he only wanted a muse for his poetry.

i'm the little girl,
the woman,
the queen,
a fucking masterpiece,
who doesn't need anyone
but me.

DON'T WORRY, LOVE.

YOU'LL BE THE WOMAN YOU ARE MEANT TO BE.

KEEP CHARGING FORWARD

THROUGH EVERY OBSTACLE LABELED "NO".

IT'S TIME TO SHOW THEM

HOW STARS TRULY GLOW.

I need you to be strong

this world will always try to break you.

They will tell you

how you're not enough.

Tearing the seams,

breaking your skin

to steal your light

and drain you dry.

No, Darling,

you're much more than that.

You're stardust and magic.

You're bones and glory.

You're everything they're scared of,

you're filled with stories.

So, be brave.

Be strong.

Show them what it looks like

to never be the star

that falls.

Dear Soulmate,

Thank you, for not being here just yet.
~~For giving me the time~~
~~to breathe,~~
~~to be,~~
~~to regrow my wings.~~
There are depths of me
that I've yet to discover
and I'd like to explore myself
further ~~before I let you in.~~
I'd like to be whole ~~again,~~
~~perhaps~~ for the first time
in my life.
~~You might have to wait a bit~~
~~longer, for that I am sorry.~~
~~But I promise you~~
~~when the time is right,~~
~~I won't be scared~~
~~of the jump,~~
~~the fall,~~
~~the flight.~~
~~Keep dreaming,~~
~~keep living,~~
~~keep loving.~~
~~You have no idea~~
~~how proud I am of you,~~
~~how badly I just want to kiss~~
~~you, to hug you.~~
~~To be with you.~~
~~But our time will come~~
~~and when we see each other,~~
~~promise me~~
~~you'll take my hand,~~
~~graze your thumb across my~~
~~knuckles and fly us~~
~~Home.~~

Your Equal,
LJ

Dear Soulmate,

I know I said I would stop writing to you, and I am. This is the last letter. The last of the lasts. I promised myself it would be because this chapter of my life needs to end.

I was going to write to you about my adventures across Europe. I was going to tell you about my worries, my happiness, my healing process. Everything because there is so much I want to tell you. Then I realized, I didn't want to write to you anymore. The words were there, ready to be captured in my journal but everything felt different.

I felt like the shell of who I was finally unveiled who I am—who I'm meant to be. It's like I can finally see the light and where it's pointing.

You're out there living, not reading these letters. You know of my existence but not who I am. Like I said, I am your dream girl and I am real.

I am waiting here still.

I've always believed in you, even at the times I've doubted your existence. Even cursing you out in a previous letter because I couldn't understand why the Universe wouldn't let you save me. I figured that out too. I needed to work through my trauma because while you're busy saving everyone else, no one is saving you. Us.

When you have no one to rescue you, you learn that empathy and hope are not only keys to surviving but living too. I can only imagine how large your heart is. I can tell you that I am worthy enough to carry it.

I'm not writing to you anymore because not only do I need/want to close this chapter, but I don't need these letters to heal my loneliness anymore. I don't need these letters to find you and I especially don't need them to cope with the trauma I was struggling to digest.

It was on my flight from Heathrow to JFK that it finally sunk in. I'm living my own love story. Embracing and enjoying all life has to offer me. I'm incandescently happy alone... that's never happened before. Loneliness used to devour me and here I am enjoying my own company.

I didn't write a poem or a story the entire trip. I was healing without writing, a first for me in my life.

On this final flight home, I knew deep within my heart that my craters were filled with gold and the remaining pieces had become whole with new dreams. What I'm attempting to articulate is that I don't need to hold onto you as tightly as I have my entire life.

I always thought that I needed to find you to be fulfilled, to be safe and experience love. I held onto you when I had lost all my hope, especially when it was taken from me. I held on because the idea of you was all that kept me alive for quite some time.

Thank you, but I'm letting you go now.

I don't need these letters to survive or to live. I don't need you either. But one day, we'll meet, and you'll eventually have the courage to ask me why I stopped writing these "Dear Soulmate" letters.

I'll tell you as I graze my thumb across your hand, with a gentle smile on my lips, "you are sunlight, but I do not need you to see the light in my darkest days when I am made of sunlight too."

So, this is goodbye. A long-winded goodbye, to you in my letters and poems. I have a new subject to explore, Me.

Until the stars deem it our time for us to be together, I'm going to live for me.

I'm going to write for me.

Your Equal,
LJ

Dear ~~Soulmate~~ Me,

I want to apologize for it taking me so long to figure this out. That you are your own soulmate, first and foremost.

I never gave you the space to be. Instead I inflated your dreams with false realities and a relentless hope that you needed another soul to be happy. I didn't know any better, but now I do. I promise I do.

You have survived more than I thought possible. You have survived so much pain, I'm not even sure how you continue to smile...yet you do. You always do now that you can.

There's courage in living, in continuing when you've been given such a hand from the heavens. Your bravery, your light, it's overwhelming. I'm not sure why I wanted to drown that light out with anothers and I'm so sorry for doing just that.

I should have been encouraging you and your dreams, not siphoning all of your hope to fall in love with another being. Disney wasn't helpful. Even your unhealthy dose of romantic comedies you watched growing up, not so great. Life is not a romantic comedy. You know first-hand, don't you? Your life is very, very far from ever being one.

You have dreams though. Ones I know you'll accomplish. Now that you have taken your relentless hope and guided it towards your goals rather than finding a man, you're going to be unstoppable. I have your back.

You used to think you were a princess, after all, you needed to be a damsel to be saved by a prince. Instead, you finally chose your own voice. You finally chose yourself. You did your best to follow along with being a princess until you realized you could be a Queen instead.

Why have a prince or a king, when you can have your own castle? Your own empire that includes an exclusive treasury, following your dreams and accomplishing everything you put your heart to. Why rely on them when you can have friendships with other Queens ruling their own lands and discussing world peace and poetry? My goodness, why would you want to pass up on that?

Why did I force you to for so long?

Remember when you wrote, "do you really think you're Irreplaceable? A king is rarely remembered, a Queen always is."

Well, I remember. Because that was your truth. There are always kings throughout history, mainly known to be mad or war heroes...but never kind. Queens though, we're always remembered throughout history. We're always remembered.

I am apologizing because you deserve a better narrative than the one I was supplying to you. Now you have it. Now it won't ever go away.

Your happy ending isn't only a carriage with your husband beside you. It's living your truth. It's traveling, it's eating, it's meeting other Queens, it's writing, it's reading. It's everything you have to offer this world and more.

You don't need a goddamn soul in this life but your own. I should have never made you think otherwise. But now I know, too. And I'll never give in to another prince with beautiful cerulean eyes. I'll never let you drown again.

You have accomplished so much from last year to now. You're an entirely different person. There's a crown upon your head, there's a sword in your hand, your pen. I'll never let you down again. You have accomplished so much, and you have so much more to go. Every punch life throws at you, I swear, you hit back harder and with a softer smile than before. You are a miraculous being.

Together, this time. Imagine how our empire will transpire. How it will expand and prosper. You were not placed in this world to be only someone's soulmate; you were placed in this world to change life. Whether it's your own or someone else's.

I will not stand in the way ever again, Love. We will heal, we will grow. Because that's what Queens do. They wear their crown; they raise their chin and they walk forward into the light like the ones before them.

I love you for who you were, who you are and who you will become. I love you always, just like the rising sun.

Your Equal,
LJ

This is the end.
The end of a fantasy.
The end of a soulmate
being someone other than me.

This is the end,
so I can begin.
This is my new beginning.

My wings have broken the cocoon of
the shell I used to be.
And with black feathers dipped in gold,
these are the wings of stories untold.
I will fly, far up in the sky,
towards the Cerulean gates of heaven.

Gold, I was told they were but
that's all a lie made up by men with
deceiving pens and Cerulean eyes.

Cerulean.
That's why so many of us don't see
the gates above.
We're blinded by the eyes
with the promise of Love.

I was never in love with
those men, the ones with
typewriters and paints
and fountain pens.
I was in love with
who I saw within them.
I was in love with my own reflection.

Cerulean
gates that have finally opened,
because I flew high
enough to reach them.
to open them by myself.
For myself.

This is the end.
The end of a fantasy.
The end of a soulmate being someone
other than me.

This is the
end of
Cerulean.

And the
beginning of
Me,
of viewing a world
within the clouds
peering down at the ground
and seeing all those I left behind.

Cerulean,
this is the end of you
and the beginning of
Me.

A C K N O W L E D G M E N T S

To Alex,
You helped me see, when I was blind. You helped me listen, when I could not hear. You helped me feel, when I was numb. You gave me the tools and support to break free. Without you, I would not be the woman I am today. I am very grateful for your friendship and your guidance. You are a remarkable woman and I am honored to know you and call you my chosen family. Thank you for everything. I love you.

To my best friend, Mara,
You're in my heart, my memories, my bones. Until we meet under a different sky, I'll always hold you safe inside. I'll always love you.

To Angelina,
Thank you for being here, always. I would not be here today without you. I know you don't like emotional shit, but it's true. You were the first one who saw me. You are my family too. I love you.

To a Poet,
"I was lost till I found you. now these songs will hold and hide your name." -Dermot Kennedy. La seule façon de fleurir est à la lumière.

The Poodles, the best goddamn girl gang around. Emmi, you're a Queen and my soul sister. Elias, because what are Spotify playlists and park benches without you? Samson, for the poem that reminded me of my worth. Kelcy, because you believed me when no one else did. My family, thank you for the poetry.

And lastly, you.

Thank you for giving my words your time and affection. If you'd like to read more of my work, you can find me on instagram @lafleurbooks.

LJ LaFleur was raised in Honolulu, Hawaii and currently resides in Southern California.

She adores rose gardens, the sea, chamomile tea, photography, Italian chocolates, Fitzgerald, Van Gogh and mint-chip ice cream.

Cerulean is her debut poetry collection.

Follow her on instagram, @lafleurbooks

CPSIA information can be obtained
at www.ICGtesting.com
Printed in the USA
JSHW020932211219
3069JS00002B/2